APERTURE

The Encompassing Eye: Photography as Drawing

As the central role photography has played in contemporary art and culture is increasingly recognized, it becomes important to examine its links to other visual media. Considering the parallels between this machine-aided medium and drawing, the prototypical art of the hand, may throw light on the nature and uses of both.

As Robert Harbison points out, William Henry Fox Talbot invented photography in part as a result of his frustration at being unable to draw; Weston Naef notes that the first commentators on the new medium repeatedly compared it to drawing. As time went on, the connections between the two media were obscured, and photography was held up as the pictorial delineation of the face of reality. The medium took on an unparalleled degree of authority and a seemingly impenetrable aura of veracity.

In the 1920s a generation of artists, led by Man Ray, the Surrealist in Paris, and László Moholy-Nagy, the Hungarian constructivist and Bauhaus teacher, turned to photography, fascinated with its seeming authority yet determined to apply it to make pictures that challenged accepted notions of reality rather than certifying their validity. As Merry Foresta writes, this process involved a revolution in the uses of photography that paralleled, and developed out of, similar discoveries in painting and the other arts.

Many photographers and artists in other media have come to use photography in ways that combine its function as a record-making medium with attention to its expressive qualities of line and tone. Robert Rauschenberg deliberately blurs the boundaries between media, creating works in which photography, drawing, etching, and other processes are seen as equally valid ways of making art. For Peter Campus and David Hockney, computers add another level of complication, allowing them unprecedented control over the image—not only through the familiar tools of framing and selection, but point by point within the image, to change or add to every aspect of the picture. For Ellsworth Kelly, photographs serve as a kind of sketchpad, to record observations in a straightforward, uninflected way.

"The Encompassing Eye: Photography as Drawing" offers an alternative way of considering the nature and functions of photography. It attempts to point to a better understanding not only of the medium itself, but of how it fulfills the human need to make pictures in order better to comprehend the world and ourselves. What forms that need may take in the future remains to be seen, as we surround ourselves with new tools—which promise to affect our understanding of the world just as photography itself has.

The publication of "The Encompassing Eye: Photography as Drawing" accompanies an exhibition of the same name curated by Charles Hagen and mounted by the Emily Davis Gallery at the University of Akron. Following its Fall 1991 premiere in Akron, the exhibition will tour nationally. Both the exhibition and the publication are supported in part by grants from the Visual Arts and Museum Programs of the National Endowment for the Arts.

THE EDITORS

Decoding the Cipher of Reality:
Fox Talbot in His Time

By Robert Harbison

Of all strange births, William Henry Fox Talbot's invention of photography was one of the strangest. The crucial event, at least according to his own account, happened on his honeymoon in Switzerland: he was making a sketch by a lakeside with the help of a camera lucida, and grew frustrated at the results. Looking at some of his sketches now, we can understand his disappointment. Extremely talented in many fields, he was a halting draftsman who depended heavily on a ruler, as well as on the optical aids of the camera obscura and lucida. His humiliating experience at Lake Como made him think very hard about how he could fix the images the camera made, and let it take the act of drawing out of his hands entirely.

As Talbot saw it, he would thus coax nature to be the artist. So his photography had picturesque origins, and his first name for his images was "photogenic drawings." Daguerre was a painter and Fox Talbot a gentleman scientist, but one can misunderstand him very badly if one attempts to fit him with a twentieth-century definition of the scientist.

Not that he was an eighteenth-century dabbler; no one could have been more wholehearted in his devotion to learning. But if study wasn't a hobby, it wasn't exactly a profession either. He didn't need to settle into one kind of science, because he didn't need to be gainfully employed or to answer to anyone. He could follow the logic of the subject or his own temperament, whichever determined the special configuration of his pursuits.

From an early age he was driven to find

William Henry Fox Talbot,
The Pencil of Nature, title page, 1844

out things. At eight he ran about in All Souls library, Oxford, taking in the presence of a splendid orrery at the edge of his vision. He saw a telescope, he wrote later, and thought it exactly like a cannon, "only bigger." Extremely early the pattern was set: his demanding and approving mother played an important part; from his first appearance in any observer's description he is said to possess formidable mental powers and confidence. As a student at Harrow he enjoyed a robust diet of cakes and games, while arranging space at a local blacksmith's for the dangerous explosions that accompanied his chemical investigations, and indexing the flora of the neighborhood with a friend.

From our perspective the constellation of his interests makes a sort of poem. The leaps which get us from one of his mental homes to the other are the greatest excitements generated by his career. How do crystallography, Egyptology, math, botany, etymology, and a passion for weather and light—each of which, at one time or another, occupied his attention—fit together?

His way of pursuing each of these interests was rigorous but intuitive, concentrated but anti-systematic. He looked for certain forms of order: familiar pieces of information were placed in novel relation to the rest, and often enough a kind of explosive connection would result. We can follow the process a couple of times in the realm of photography, but of course for Fox Talbot that wasn't an especially preeminent subject. It appeared and disappeared, waxed and waned in his mental sky, pushed out at times by the study of hieroglyphics and cuneiform writing, or modulating to a study of phosphorescence, as it had in part sprung from his investigation of flame-colors.

The kaleidoscopic play of his interests explains in part why Talbot lost out to Daguerre. After a year or two's intensive devotion to sun pictures he virtually gave them up, until stirred into activity again by the news of the Frenchman's imminent announcement. The kaleidoscope is not an utterly opportune image. This instrument was discovered and became a fad when Talbot was a student, and earned his scorn for broaching physical questions superficially, not deeply. His approach only *looks* kaleidoscopic: the universe presents us with a series of pro-

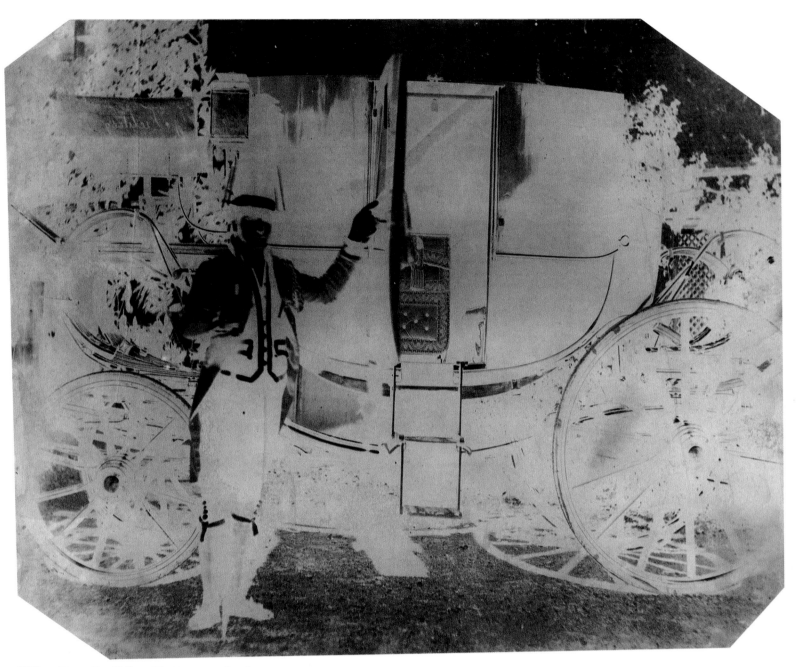

William Henry Fox Talbot, *The Footman*, October 14, 1840

Every other experimenter that I have read of tried to find a way
to eliminate the stage in which a negative image occurred, deeming it
useless and inefficient. To Talbot, the negative had a beauty of its
own and granted a particular insight into the nature of light.

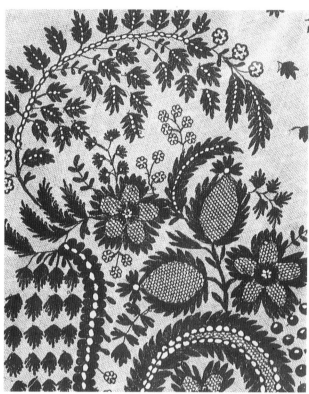

William Henry Fox Talbot, *Lace*, 1840

William Henry Fox Talbot, *Solar Microscope Magnification*, n.d.

found riddles it is our highest function to begin to unravel, thus allying ourselves more firmly with great and fruitful processes.

A correspondent wrote to Talbot in 1855 saying that photography was one of the great "poet-ideas" of the century, and it is fair to say that this is how he saw it. This medium made a kind of union between man and visible reality, allowing us to look more deeply into all that surrounds us. He delighted to pore over his lilliputian images long after taking them, uncovering with a lens fresh details never seen before. The photographic image was more intricately coded than natural vision, because it held the data in suspension until you were ready to absorb it. We have grown used to the process, but for Talbot it retained its halo of the miraculous.

The subjects of the earliest pictures are in certain ways purer than any that have followed. The objects to be recorded were often laid right on the paper. Thus the results are much nearer to eighteenth-century silhouettes, though it is not only the outline which was transcribed.

Before reading Talbot's reflections on the procedure, one forms a certain conception of the family made by these various classes of objects: leaves, lace, feathers, flys' wings. At least in black and white they verge on spiritual or theoretical substances, of which a picture and an X-ray would be much the same. They are practically weightless, semi-transparent, idealized by colorlessness. Of course there is the spectral repigmentation caused by different chemicals on the paper, rose, saffron, and violet being the main hues, as if this science were placed incon-

gruously under the tutelage of flowers. In light of this it comes as quite a shock to read that Talbot regards all these exceedingly poetic substances as above all flat objects.

Still, the earliest photographic images are ghosts in more than one sense, and we would be very reluctant to give up the poetry of the process by which they were arrived at. But to produce them needed in the same person the dreaming dilettante and the hard-headed experimentalist.

Not that Talbot's interpretation of practical advice and laboratory results wasn't often imaginative in the extreme—for example, the discovery that *less* salt in the solution gave more of the effect the salt was there to produce. In order to *see* this, in peripheral indications on one of his sheets, he had to be able to turn his thoughts inside out, a

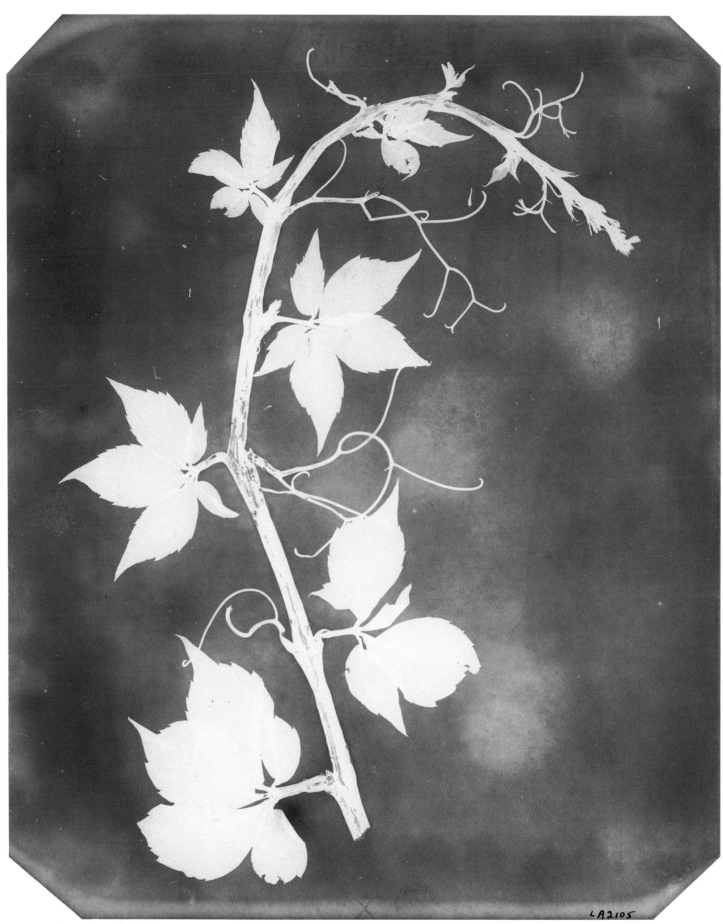

LA2105

William Henry Fox Talbot, *Photogenic Drawing Negative*, 1838–39

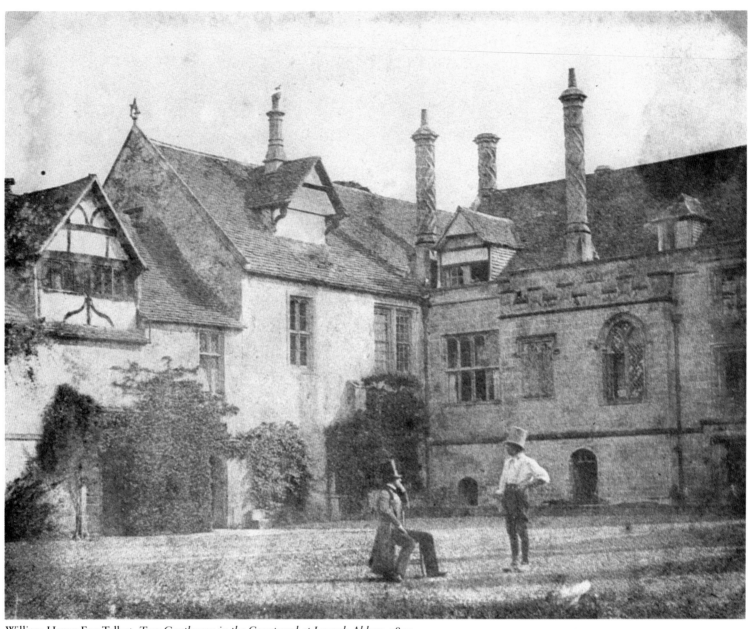

William Henry Fox Talbot, *Two Gentlemen in the Courtyard at Lacock Abbey*, 1841

process something like allowing irony to play across one's most cherished beliefs. An even more striking case is what he did when confronted with negative images. Every other experimenter that I have read of tried to find a way to eliminate the stage in which a negative image occurred, deeming it useless and inefficient. To Talbot, the negative had a beauty of its own and granted a particular insight into the nature of light. More important than this, he saw instantly that the negative could be used as a template if one registered it on a transparent medium; by

Lacock is the sort of place around which ghosts of the departed nuns could easily be made to flit, an apt setting for gloomy Gothic novels.

shining light through it onto other sheets of sensitive paper, one could then produce large numbers of copies easily.

Talbot's process embodies many more acts of extreme mental flexibility than

Daguerre's; it is a less rigid and more employable solution. Stranger still, it remains nearer to its roots in human pictorial art—paper is a more humane and immediate medium than the metal plate.

In an almost obtuse way, Talbot remained near his picturesque roots. He became tired of photographing Lacock and hankered after cathedrals and seaport towns, real picturesque subjects. To modern eyes this is so far from what's needed to legitimize Talbot's early photographs that we tend to dismiss it. But as with other early practitioners, the retro-

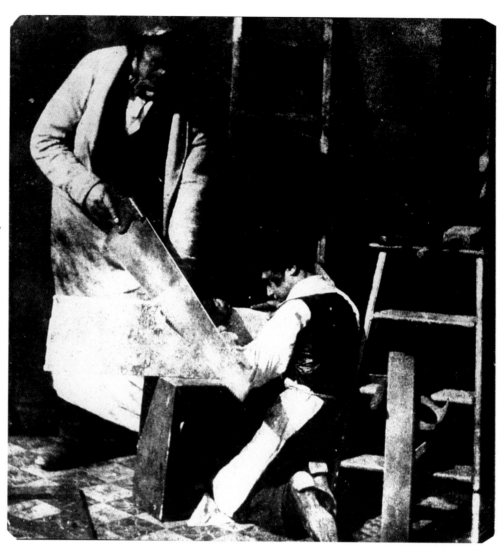

A correspondent wrote to Talbot in 1855 saying that photography was one of the great "poet-ideas" of the century, and it is fair to say that this is how he saw it. This medium made a kind of union between man and visible reality, allowing us to look more deeply into all that surrounds us. We have grown used to the process, but for Talbot it retained its halo of the miraculous.

William Henry Fox Talbot,
Carpenter and Apprentice, mid 1840s

grade elements in Talbot's makeup have real staying power. The subjects of his photographic books after *The Pencil of Nature* are revealing, beginning with a pilgrimage round the scenes of Scott's novels and ending with *Annals of the Artists in Spain*. An element of angling for a market might be present here, but then his first publication was a collection of Gothic tales. It's all the more surprising that he remained largely immune to the charms of the family home, Lacock Abbey.

This is one of the great collocations in the history of photography—the numinous location and the imaginative scientist. Lacock is a strange amalgam of real and pseudo- or literary Gothic, with the latter now predominant. It is the sort of

place around which ghosts of the departed nuns could easily be made to flit, an apt setting for gloomy Gothic novels.

It may be only a stableyard opening, with a ladder reaching up to it, but pictures of an *abbey* are poignant signs of this medium's attempts to tear itself away from the past and old ways of seeing. Harsh sunlight and mellow walls, people still as statues and a kind of mist surrounding them—these images from Lacock enshrine some of the richest contradictions in the position of photography at its beginning.

If Talbot is in some ways a conventional follower of conventional taste, he could also turn a powerful searchlight on human perception. His analysis of what the camera image really is probes very

deep. Some of his scenarios at the edges of the visible, recounted in *The Pencil of Nature*, read like Poe stories. He imagines a room full of people who can't see each other, and a camera trained on them long enough to see them and reveal their secrets, the suggestion being that in the right setting the camera would possess a kind of psychic, not just physical, penetration. Even his most inert subjects, the carefully laid breakfast tables or shelves of books, make an importunate plea like souls that need attending to. As formal compositions they are usually sub-banal, but as messages or overtures made by reality they have arresting force.

As a student Talbot was seen as refreshingly unlicked and not a fine gentleman, a person whose ruling passion was a thirst

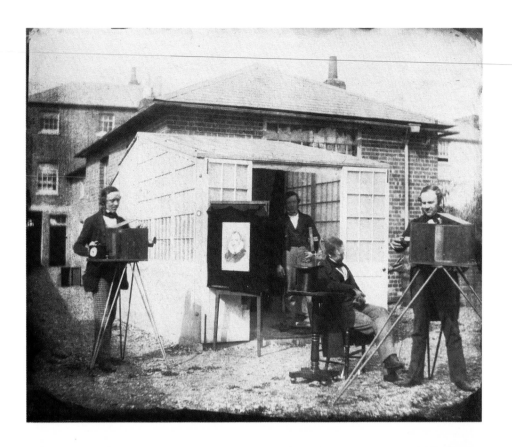

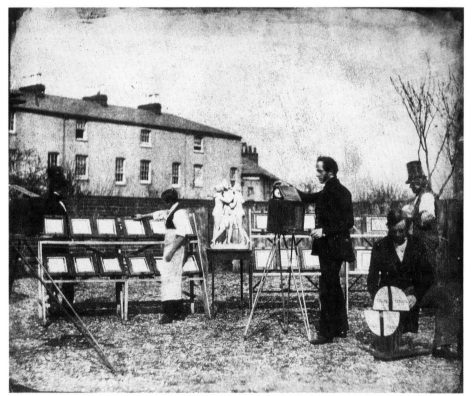

Attributed to Rev. Calvert Richard Jones, *The Reading Establishment*, mid 1840s

to know. He was drawn to learning as naturally as an otter to water, a friend said. So powerful were the intellectual passions that the social man remains indistinct. He was affable and well liked but hated business and practical affairs, becoming increasingly less tolerant of meetings and society as he went on. No one can explain why he decided to enter Parliament on the Reform side. He wasn't a political animal and had soon had enough, so he didn't stand for election again.

But even his consuming intellectual pursuits would grow suddenly cold. Both

The earliest photographic images are ghosts in more than one sense. . . . To produce them needed in the same person the dreaming dilettante and the hard-headed experimentalist.

photography and mathematics passed out of his life for long periods. After 1851 he had virtually ceased taking pictures. The wrangles over his patents, however, went on. These devices were not a success: Talbot had foreseen large profits from commercial exploitation of his ideas, but the principal effect of the legal restrictions he erected was to suppress the spread of the calotype process he'd invented.

Assyriology looms much larger than photography near the end of his life. He wrote seventy articles on this subject, and tried to stage a multiple-blind translation of cuneiform text to stir up sluggish public interest in this mysterious field. Although he appears not to remain true to some of his earlier pursuits, photography prominent among them, the consistent principle in Talbot's life stays steadily the same: he was always unraveling something. To make an image appear on a blank sheet, to produce a meaningful text from a confusing multiplicity of marks—there are powerful similarities here.

In both cases Talbot is forcing the world to materialize or declare itself. The image or text may contain an irreducible element of strangeness, but the fact remains that it is there for all to see, *something* in place of nothing. □

Talbot Today: Changing Views of a Complex Figure

By Michael Gray

William Henry Fox Talbot is now recognized as the single most important figure in the formative years of photography, and the events of his life between 1833 and 1840 have been recounted in numerous publications over the years. However, as new research is brought forward, a more human and sympathetic picture of Talbot's character begins to emerge. No doubt further study will reveal other aspects of his life, building upon and complementing the excellent biography written by H. J. P. Arnold in 1977.

The best-known version of the story of how he came to invent photography is that recounted by Talbot himself in *The Pencil of Nature*.[1] But a more poetic and lyrical version was written by another scientist, related to Talbot by marriage, Nevil Story Maskelyne of Bassett Down, near Swindon. In an unsigned article in *The National Review*,[2] Story Maskelyne wrote: "It was on that beautiful Italian water whose triple arms converge on the point of Bellagio that Mr. Talbot longed for a power to enable him to bear away an image of the soft silvery radiance of Lecco and Como. There he resolved to work out the problem by which Nature herself would be induced to perpetuate the outline of her own beauties in an artistic form."

Talbot had made several extensive journeys through Europe in the 1820s, including one tour in 1826 that included Corfu, where he was, in his own words, "in search of the picturesque."[3] The Italian lakes certainly held a fascination for Talbot, and were the subject of his first published work. In *Legendary Tales*, a series of short stories by Talbot published by James Ridgeway in 1830, two stories are of particular interest in relation to his later work in photography. The first, "The Magic Mirror," is a dark Gothic poem that features a mirror which depicts a landscape of great beauty and wonder. The other, "Rosina," is a romantic and ethereal story set on the shores of Lake Como. Talbot constructs the story in such a way that it is difficult to distin-

William Henry Fox Talbot, *Lacock Abbey*, 1835
(Courtesy of the J. Paul Getty Museum)

guish reality from dream. Both stories reveal a side to Talbot's character hitherto unseen.

It is now becoming apparent that Talbot sought to explore the relationships between disparate disciplines that he studied separately. For example, he may have taken the idea of the latent image from his experiments with secret writing (which he referred to as "sympathetic ink"). In a letter from the 1820s his half-sister Horatia Feilding wrote: "We tried your experiments of sympathetic ink by the fire—the black one came out directly very black & has remained ever since. The blue appeared by degrees & got very bright it has since nearly vanished but not entirely." She then exclaimed, "How came you to discover it!".[4] In an earlier letter Talbot had apparently included two pieces of chemically treated paper; sadly, these items are no longer part of the Lacock Archive, although Harold White noted their existence in 1957.[5]

This letter provides the earliest known reference to Talbot's experiments with secret writing. The letter relates directly to one of the few references to secret writing in Talbot's Notebook Q,[6] in which he gives the formula for the successful black result. These experiments may have implanted in Talbot's mind not only the concept of the latent image, but also the idea of developing that image by use of organic chemical reagents.[7]

Without doubt Talbot's longstanding interest in botany led him to use botanical specimens as objects for contact printing while he was conducting his early experiments with silver nitrate and silver chloride. Being a member of the

Linnean Society he would have seen examples of nature printing, of which several can be seen in their archives. Photogenic drawings of botanical specimens form the greater part of Talbot's earliest work; camera pictures, either in negative or positive form, are much rarer.

In the nineteenth century, philology was defined as the science of language, and throughout his life Talbot was actively involved in the study and analysis of words, working in a sense as a linguistic archaeologist. For example, in his Etymological Notebook S3 he focused on the word *Protogenia*: "Protogenia, was she not the daughter of Neptune? no, of Denealion. But was not he the sea? The *Deluge* of Denealion. Besides Protogenia, first born, is unmeaning—as applied to a *mythical* personage."[8] It may not be unreasonable to make a link between this etymological exploration and Talbot's picture-making activities, given that changing a single letter transforms the word into *photogenia*.

As more and more details of Talbot's life and work become known, the accepted view of his achievement—which still rests largely on his own interpretation in *The Pencil of Nature*—will no doubt undergo substantial change. As this happens we may gain a greater understanding of this complex and fascinating man, and of his relationship to his, and our, times. □

1 "The Pencil of Nature," published in six parts, 1844/1845. 2 "The Present State of Photography," No. XVI, April 1859, pp. 365-392. 3 Lacock Abbey Correspondence LA20-26. 4 Lacock Abbey Correspondence LA32-9. 5 *Sun Pictures* Catalogue Three, by Hans Kraus, Jr. and Larry Schaaf, New York: 1990, p. 90. 6 The Science Museum Collection, London. 7 M. Neirenstein, "The Early History of the First Chemical Reagents," *Isis*, 16, pp. 439-446 (1931). 8 Lacock Abbey Collection Notebook S3, entry dated September 12, 1836.

William Henry Fox Talbot, *Villa Melzi*, 1833
(Courtesy of the J. Paul Getty Museum)

9

Daguerre, Talbot, and the Crucible of Drawing

By Weston Naef

Still astonishing in its coincidences, the story is well known: in January of 1839, the world heard two nearly simultaneous public announcements that sunlight had been harnessed to make pictures, one from Louis-Jacques-Mandé Daguerre in Paris, the other from William Henry Fox Talbot in London. What is seldom commented upon, though, is the fact that lacking other ways to make understandable their prodigious discovery, both inventors described their creations as types of drawing. In the first printed matter explaining the principles of the new picture-making systems, references to drawing abound; however, no explanations were offered that might amplify the perceived relationships between drawing and the new processes. Examining the theoretical and historical sources for these inventions may help clarify why they saw the new medium as a type of drawing.

The first public exhibition of the new species of picture that eventually came to be called a photograph occurred on January 25, 1839, when Talbot sent a set of specimens to London's Royal Institution. There they were put on display in the association's library for viewing after a lecture by Bernard Woodward entitled "On a New Apparatus for the Public Demonstration of the General Properties and Laws of the Polarization of Light."[1] It was fitting that the first public display of a collection of photographs should take place in the context of a lecture on the properties of light, since the word "photograph" may be translated from its Greek roots as "drawing with light."

It should be noted, however, that the word "photograph" did not spring immediately into use: instead, phrases that suggested a relationship between drawing and photography were invoked to describe the new pictures. Following Woodward's lecture, the chairman of the session, Michael Faraday, invited the group to view "drawings in the library, sent there by H. F. Talbot, F.R.S., and by him named 'photogenic drawings.' "[2] A report on this meeting published in the *Literary Gazette* described the pictures that the audience saw as follows: "No human hand has hitherto traced such lines as these drawings displayed; and what man may hereafter do, now that dame Nature has become his drawing mistress."[3]

The following week, on January 31, Talbot delivered his first public lecture on his experiments with the light-sensitive properties of silver chloride, at the meeting rooms of the Royal Society (incorporated in the mid-seventeenth century as the Royal Society for the Improvement of Natural Knowledge). His talk was entitled "Some Account of the Art of Photogenic Drawing, or The Process by Which Natural Objects May be Made to Delineate Themselves Without the Aid of the Artist's Pencil."[4]

William Henry Fox Talbot, *Linen textile fragment*, c. 1835

Specimens of photogenic drawing were on display at the Royal Society for study by those who attended the lecture. Shortly afterward the lecture was published as a pamphlet that contained the most complete description in print of how sunbeams could be harnessed. It must be remembered that there was no way to reproduce photographs in publications, and reporters had to rely exclusively on words to describe to their readers the novel properties of these new images. In these first announcements of the British discovery of photography the inventors searched for the closest analogy they could imagine to communicate to readers who had no opportunity to see specimens of the new art, and the closest analogy was to drawing. The comparison of photography to drawing remained prevalent for several years, and as late as 1844 Talbot entitled his first book-length description of photography *The Pencil of Nature*.[5]

The flurry of scientific meetings in London in January, 1839, was spurred by a rumor circulating from Paris in the first week of that year that Louis-Jacques-Mandé Daguerre had discovered a way to make pictures with light.[6] Like their English colleagues, the French reporters who chronicled Daguerre's discovery made a similar comparison of the new process to drawing. In his *Report* to the Chamber of Deputies during its second session for 1839, the influential scientist François Arago referred to the

pictures made by Daguerre as "Mr. Daguerre's drawings,"[7] and compared daguerreotypes to drawings seven times in his text. Paul Delaroche, the painter whom Arago quoted as an expert witness, also referred to the specimen daguerreotypes as "Mr. Daguerre's drawings."[8]

We do not know for certain which of the surviving photogenic drawings Talbot sent to the Royal Institution and to the Royal Society for their January meetings. However, we do know that Talbot had not worked with light-sensitive materials between 1836 and January, 1839, and therefore the specimens he showed must have been left over from his first experiments of 1834–35.[9] The results were outlines of plants and silhouettes of roof lines

For scientists, artists, and connoisseurs of art, drawing represented the rationalization of sight, and photography was yet another step in the process of making visual perception understandable and explainable.

of buildings against the sky. The audience at the Royal Institution would likely have seen a photogenic drawing such as the *Study of a Textile*, and the exterior study of the roof line of Lacock Abbey. The image of the textile fragment was created by placing a piece of cloth directly on the light-sensitized paper and exposing the paired elements to sunlight, whose chemical action on the silver chloride caused the shadow of the cloth to be recorded. The picture of the roof line of Lacock Abbey was made by exposing the paper in one of Talbot's earliest cameras, a small wooden box fitted with a lens. Both of these pictures are negative images in which the tones of nature have been reversed. It was not until 1840 that Talbot was able to devise a way to turn negative images into positives.

Likewise, we do not know exactly which daguerreotypes Arago examined in preparing his report to the National Assembly. We do know, however, that at first Daguerre was unable to make portraits with his new process, and that his earliest experiments were in copying engravings and in photographing still life arrangements. Daguerre's pictures had much greater detail than Talbot's, and looked more like photographs as we

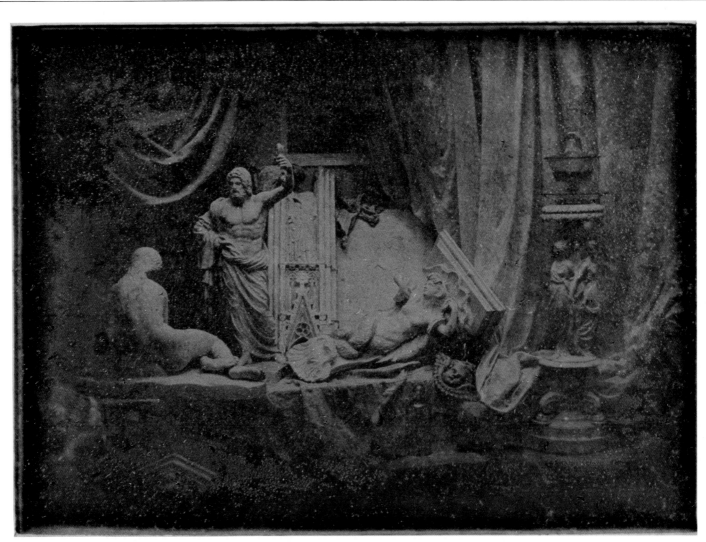

Louis Jacques Mandé Daguerre, *Still Life Arrangement*, c. 1839

Charles Hayter, *Drawing students looking at the horizon*, from *An Introduction to Perspective, Drawing and Painting*, London, 1835

From the mid-seventeenth century onward drawing was considered an essential subject for educated persons among the upper classes of Europe, who were taught by instructors such as the one represented in Jan Steen's painting entitled *The Drawing Lesson*, of about 1665. Drawing could not become a subject for general education, though, until first paper and then drawing implements became widely available around 1450, and until artists themselves came routinely to practice drawing on paper as an action independent of painting, which was not the case

In order to learn to draw landscape in the 1820s a person would have turned to a drawing master and the instructional manuals of an artist like Charles Hayter, for whom perspective was "the foundation of truth in a picture."

until about 1500. By the seventeenth century, though, drawing had become widespread, and was practiced by professional artists and amateurs alike.

A drawing class and the repertory of implements required for the professional draftsman in the mid-eighteenth century is shown in a series of engravings created by Nicholas Cochin the Younger. Accompanied by the descriptive texts of Denis Diderot, these engravings appeared in 1763 in the supplementary plate volume to Diderot's *Encyclopedie*.[9] The plates illustrate the wide variety of tools used in drawing at the time, including the most essential: a point for drawing the line, a straightedge, and a support such as paper to draw upon. The use of mathematics and sophisticated tools from copying such as a walk-in camera obscura and a pantograph can also be seen. Cochin even presents a diagram of the interior of a drawing academy, with students engaged in receiving various types of instruction. In the left foreground, students are copying a drawing that hangs from an easel; behind them, another group of students draws from plaster casts illuminated by an oil lamp suspended overhead, while other casts can be seen hanging on the wall at the left. (The casts depicted by Daguerre in the Metternich plate had not changed significantly from those of Cochin's time.) At the center, other students draw from a live model. Daguerre no doubt learned to draw in an environment such as this, while Talbot, who never studied in a drawing academy, probably learned what little he knew about drawing from a textbook with coaching from his wife, Constance, who was proficient in the art.[10]

By the early nineteenth century most well-educated individuals were schooled in perspective and figure drawing, which was considered a skill as important for personal development as handwriting. Perspective drawing was regarded as both a craft and a branch of mathematics and philosophy. It was seen as not just a way to create a picture, but a means as important as poetry

know them today. It is likely that Arago would have seen an image similar to the daguerreotype depicting a still life arrangement of plaster casts and drapery that Daguerre presented as a gift to Prince Metternich in 1839, and which at this writing is in the custody of the National Technical Museum in Prague.

It is somewhat surprising that in the first printed references Talbot's photogenic drawings and Daguerre's daguerreotypes should both be likened to drawing. The results of the two picture-making systems are quite dissimilar, and neither system closely resembles drawing in its physical characteristics. It can be deduced that the early analogy between photography and drawing was invoked because people saw an organic relationship as well as a visual one.

The discrepancies among the look of photogenic drawings, daguerreotypes, and drawings leads us to ask what there is in the technique, process, or appearance of drawing that made it seem so natural, a hundred and fifty years ago, to compare photography to it. An answer to the question begins with a phrase found in the *Literary Gazette* report on the simultaneous inventions of photography: "drawing mistress" (a gender variation on the more common "drawing master" that was called for because *mother* nature was the instructor in the art of photography).

for the expression of complex and abstract ideas about nature, which by 1820 had come to be revered as the generative source for artistic inspiration.

Both Talbot and Daguerre made drawings; however, Talbot's are clumsy and stiff, while Daguerre was a trained artist whose drawings are highly refined miniatures. Talbot, whose drawings from his Italian trip of 1833 were made with the assistance of a camera obscura, was inspired to make his experiments in photography because he was so unhappy with the quality of his own

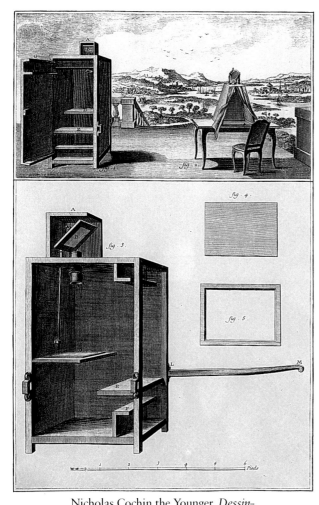

Nicholas Cochin the Younger, *Dessin-Chambre Obscure*, Paris, 1763

sketches. Talbot was interested in landscape and was frustrated by his inability to delineate the terrain of the Italian Alps, while in his drawings Daguerre was chiefly interested in depicting architecture.

By the 1820s drawing had developed into highly refined specialties based upon subject—architecture, figure, landscape—and artists skilled in one branch often were not fluent in others. A drawing specialty began to exist when it had become sufficiently rationalized that it could be taught in the academy. This was at least partly contingent upon the evolution of

Louis Jacques Mandé Daguerre, *Entrée de l'église du St. Sepulchre*, c. 1820

handbooks and manuals, the first of which were devoted to perspectival drawing, then figure, and finally landscape, which required a difficult mix of intuitive and analytical powers of observation. Architectural drawing was grounded in perspective, and in the hundred years between the mid-fifteenth and mid-sixteenth centuries it had become highly rationalized. Figure and landscape drawing were slower to evolve into teachable notational systems, but reached this point by the mid-seventeenth century.

In order to learn to draw landscape in the 1820s a person would have turned to a drawing master and the instructional manuals of an artist like Charles Hayter, for whom perspective was "the foundation of truth in a picture."[11] The lessons would include instruction in the geometry of spatial representation, in how line defines shape, and in the use of chiaroscuro to create the illusion of atmospheric volume. Hayter taught his pupils to observe the world as though looking through a window, and used diagrams that had their origins in the earliest published treatises on drawing such as Albrecht Dürer's *Unterweysung der Messung* (1525), in which we see a woodcut of an apparatus designed to assist an artist in drawing. Perspectival drawing was the first type of drawing taught in a systematic way, and Leon Battista Alberti wrote the first instructions for perspectival drawing that have survived.[12] However, his treatise of 1435,

which Dürer surely saw in manuscript form, was not published until more than a century later, by which time perspectival drawing was defined as a procedure that required at least three tools: a point with which to create the line, a straightedge to ensure accuracy, and mathematics to establish the relationships between objects in the scene.

Talbot apparently had some rudimentary exposure to such lessons on how to observe nature, but his surviving drawings, such as *Villa Melzi*, 1833, indicate that he was unable to express in freehand drawing the flow and rhythm of trees, rocks, and hills that merged one into the other, and horizons that undulated gracefully. He appears, however, to have had somewhat greater command of the more rational process of linear perspective, and for this reason seems to have been most comfortable when architectural elements allowed him to impose the mathematical relationships of linear perspective on a scene to give structure to the picture. He was also assisted by the camera obscura, the lens of which would help to rationalize the picture space by exaggerating the convergence of parallel lines. Even though Talbot evidently made the drawings from his Italian trip out of doors, he showed little sensitivity to the effects of light, shadow, and atmosphere, which eventually became major components in the grammar of photography. Talbot's training was grounded in the most traditional kinds of perspectival drawing as taught by Alberti in his *Della pittura*. His drawings express an obsessive concern for the linear elements of the scenes, and his tendency was to translate the subject into disjointed abstract shapes.

We have no documentation why Daguerre, who was also a painter, became obsessed with photography. However, it does not appear to have been because he was frustrated with his own lack of skill as a draftsman. Daguerre had received more instruction than Talbot in the science of perspective drawing, in the Ecole des Beaux Arts, where Daguerre studied lessons that would have descended from Cochin and Diderot's method of study of 1763, which taught that the purpose of drawing was to perfectly imitate nature, and thus the pursuit of truth was a goal shared by drawing and photography.

Daguerre's objective was to fuse the rationality of perspective

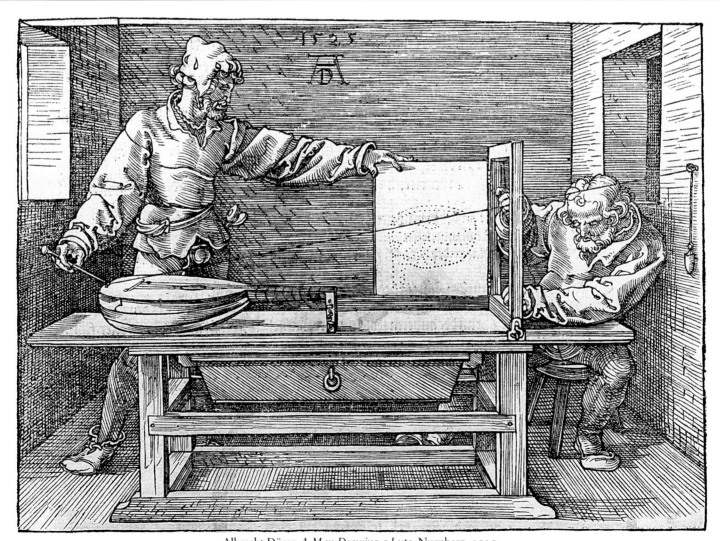

Albrecht Dürer, *A Man Drawing a Lute*, Nurnberg, 1525

with the ambiguity of figures and deep shadows. About 1827 Daguerre devised a secret drawing method, which he called "*Dessin-Fumée*" (literally, "smoked drawing"; graphite and vaporized ink on paper), that yielded images with mysteriously photographic qualities. Line and chiaroscuro were the grammar of drawing, and were skillfully combined in these images. An important difference between Talbot and Daguerre is how they chose to draw subjects that included both architecture and landscape. For Talbot, architecture provided the foreground for

Louis Jacques Mandé Daguerre, *Fantasie*, 1826–27
(*Dessin-Fumée*)

his principal subject, the landscape; Daguerre reversed the priorities and made landscape a background element behind dominant structures. As a draftsman Daguerre distinguished himself from Talbot by his sophisticated use of chiaroscuro. There was, however, also a mechanical aspect to Daguerre's drawing—an emotional distance—that separates his pictures from those of the great draftsmen of his period, whether the cool precision of Ingres or the emotive gesture of Delacroix.

For scientists like Faraday and Arago, drawing was understood to have linear perspective at its center and truth as its objective, and was a craft that required sophisticated mechanical devices to achieve the desired result. It was not at all difficult to extend the tools of drawing to include camera, lens, and chemicals. For scientists, artists, and connoisseurs of art, drawing represented the rationalization of sight, and photography

was yet another step in the process of making visual perception understandable and explainable.[13] The fact that the first published systems of drawings are found in books on perspective, and are geometrical and mechanical rather than gestural and notational in character, is important in recognizing how definitions of "drawing" changed in the five centuries between Alberti and the announcement of photography in 1839, and in grasping why Faraday and Arago referred to the products of both Talbot's and Daguerre's processes as drawings.

In 1839 everyone concerned with art understood that one school of drawing—that grounded in linear perspective—had a mechanical aspect that did not detract from either its authenticity or its integrity as a creative tool. At the time of its introduction, photography was considered as another in the inventory of mechanical aids used by artists to rationalize sight. Gestural drawing or freehand sketching was an art practiced by just one school of artists; most artists used one mechanical aid or another in creating their drawings. It was natural, therefore, for photography, which also required mechanical appliances, to be considered as simply another type of drawing by the first people who used it.

What has not been generally recognized, however, is that by the late eighteenth century drawing in its three principal types had become mechanical and formulaic. Perspective drawing had become mechanical in the extreme, because of advances in mathematics and the increasingly precise metal drawing instruments, but figure and landscape drawing had also become anti-intuitive and anti-spontaneous. The advent of photography invited the reintroduction of observation and intuition back into the process of representation. In the early years of photography it was impossible to make a photograph without observing the subject closely, and the process of close observation that from the beginning was one of the identifying characteristics of drawing was also inherent to photography. Thus it is not surprising that the earliest photographs were not only called "drawings," but were tested by the same yardstick of truthfulness that was used as the measure of drawing. ☐

1 This article is adapted from a work in progress surveying the photography collections of the J. Paul Getty Museum. 2 *Literary Gazette*, no. 1150 (2 February 1839), p. 74. 3 Ibid., p. 74. 4 [William] Henry Fox Talbot, "Some Account of the Art of Photogenic Drawing, or The Process by Which Natural Objects May be Made to Delineate Themselves Without the Aid of the Artist's Pencil," London, R. and J.E. Taylor, 1839. 5 Hans P. Kraus, Jr., and Larry Schaaf, eds., William Henry Fox Talbot, *The Pencil of Nature*, London, 1844, repr., New York, 1989. 6 Helmut and Alison Gernsheim, *L.J.M. Daguerre: the History of the Diorama and the Daguerreotype*, London, 1956. 7 François Arago, "The Report . . . By Mr. Arago, Deputy of the Upper Pyrenees . . . Sitting of the Sixth of July 1839," in [Louis-Jacques-Mandé] Daguerre, *An Historical and Descriptive Account of the Various Processes of the Daguerreotype and the Diorama*, London, 1839, p. 21. 8 Ibid., p. 23. 9 Denis Diderot, *Encyclopedie ou Dictionnaire Raisonné des Sciences, des Arts et des Metiers*, [plate volume] Paris, 1763. 10 Gail Buckland, *Fox Talbot and the Invention of Photography*, Boston, 1980, pp. 28-33. 11 Charles Hayter, *An Introduction to Perspective, Drawing and Painting . . .*, London, 1825. 12 Leon Battista Alberti, *On Painting*, translated and edited by John R. Spencer, London, 1956. 13 William M. Ivins, Jr., *On the Rationalization of Sight: With An Examination of Three Renaissance Texts on Perspective*, New York, 1938. See also Martin Kemp, *The Science of Art*, New Haven and London, 1990, pp. 9-75 and 338-9.

Tracing the Line: Art and Photography in the Age of Contact

By Merry Foresta

For sheer inventiveness, few artists of any era have matched Man Ray and László Moholy-Nagy. Between the two World Wars these artists, who counted among their multiple talents painting, sculpture, filmmaking, and photography, defined a photographic medium capable of taking on the difficult task of making art in the twentieth century. Of course many other artists contributed to the repertoire of experimental photography during the 1920s and 1930s. Extreme camera angles, tilted horizons, fragmentary close-ups, photomontages, photograms, solarizations, and the combination of photographs with moderntypography and graphic design were explored by an entire generation of photographers,

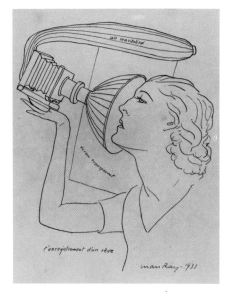

Man Ray, *L'Enregistrement d'un rêve* (The recording of a dream), 1933

among them Berenice Abbott, Alexander Rodchenko, Maurice Tabard, André Kertész, John Heartfield, El Lissitzky, Walker Evans, and Florence Henri.[1] But the decisive presences in this period of artistic innovation were Moholy-Nagy, the Hungarian, and Man Ray, the American.

The two were often confused. In retrospect, the mistake of the *New York Times* reporter who announced in 1924 the impending arrival in the United States of "Man Ray, Rumanian 'modern' and 'traveler in fantasia,' " for an exhibition of his "lensless photography and Russian constructivist paintings" seems understandable, an apt compression of artistic twins.[2] Like two scientists who make simultaneous discoveries while working in different laboratories—for Moholy, the Bauhaus; for Man Ray, his own Surrealist atelier in Paris—the two worked along paths that intersected with almost uncanny frequency.

Two late points of concurrence are worth noting: in 1936 Man Ray had begun to experiment with a variation on the rayograph, examining various ways to produce intricate patterns of line. Sitting in a dimly lit room, in front of a camera with the shutter open, Man Ray "drew" in the air with a small flashlight, tracing the gestures of his hand onto the film. In that same year he made the title drawing for his book *Les Mains libres* (Free hands).[3] While seemingly an abstract arrangement of haphazard lines and staccato dashes, the sketch suggests a tracing of the white arabesques of movement recorded in the photograph. We begin to suspect that the title of the book of drawings, published at a time when Man Ray was attempting to state a case in America for his multifaceted art, refers to the prestidigitation not only of the draftsman, but of the photographer as well.

In 1938 Moholy produced two similarly related works. A photograph entitled *Parking Lot in Winter* was reminiscent of photographs of snowy patterns he had made from the top of the Berlin Radio Tower ten years before. Such unfamiliar views, obtained by pointing the camera up or down, were part of an artistic vision that placed emphasis less on producing a document than on creating a dramatic design. The related abstract drawing—Moholy called it *Linear Mobility*—was, like Man Ray's, traced from the design of the photograph. In Chicago, as newly installed head of "the new bauhaus american school of design," Moholy's demonstration emphasized the links between art and innovation.

The conjunction of photography and drawing was not an unfamiliar one. After all, Cocteau had described Man Ray's cameraless photographs, made in the darkroom, as "paintings with light." By the spring of 1922, newly arrived in Paris, Man

Lucia Moholy, *Portrait of Moholy-Nagy*, 1925–26

For these artists it was not the photograph, the drawing, or the question of which came first that was important, but the subversion of traditional systems of rendering.

Ray was ready to embrace a new medium, one that would free him from the fierce competition of the many painters struggling in the twin shadows of Picasso and Matisse. Although he presented the invention of the photogram as a dada experiment in the workings of chance and the automatic—he "accidentally" turned on the light in the darkroom, he reported, and "mechanically" placed objects directly onto a piece of paper in the developing tray—the wizardry behind the discovery could not be hidden.

Moholy, too, sought to free himself from conventional ways of using the medium. "Drawing with light," using "light in place of pigment," were phrases Moholy used to describe his initial efforts in photography, experiments that preceded the photographs he made with a camera.[4] Moholy and his first wife, Lucia, began making photograms in late 1922, as an extension of their exploration of the artistic possibilities of new materials. By the mid 1920s Moholy's experiments with photography had moved him to give up painting and "reject all hand-produced textures."[5] His 1925 book *Malerei Photographie Film* (Painting Photography Film) predicted the coming of a modern "culture of light" that would offer creative thresholds not yet imagined.[6] To create something new, he and the other signers of the 1921 "Manifesto of Elemental Art" declared, would require "bold invention"—"the abolition of style in order to achieve style!"[7]

From the beginning Moholy was interested less in the identity of the objects with which he created his photograms than in the abstract compositions they formed. Through improvisation and conscious arrangement he produced a strange world of visions that paradoxically included realistic elements. Closely related to the geometrical abstractions of his Constructivist paintings, Moholy's photograms are as planned and controlled as Man Ray's were (or seemed to be) accidental and automatic. Yet his description of the effect as "sublime, radiant, almost dematerialized" suggests the ephemeral, X-ray quality he was after.[8]

Moholy's photograms fit into the theoretical program he laid out in "*Produktion-Reproduktion*" (Production-reproduction), an essay published in the July 1922, issue of *De Stijl*.[9] "Reproduction" in this context signified representational art; "production" involved the creation of entirely new forms suited to a technological age. By rejecting the documentary functions of recording media such as photography, film, and sound, artists could change their role from reproduction to production, from representation to invention. For example, Moholy predicted that by drawing directly and spontaneously onto a wax record, composers could create a new kind of music. In a similar way,

photographers could make images in the darkroom, without a camera, and thereby liberate the objects depicted from the world of appearances.

Where Moholy—teacher, proselytizer, and passionate theorist—expounded his ideas with ceaseless energy in books, essays, and classes, Man Ray expressed his theories more informally, often through spontaneous exclamations in letters home. Writing from Paris to his American patron Ferdinand Howald in 1922, he pronounced rayography "a miraculous process," and proclaimed himself freed from "the sticky medium of paint" to work "directly with light itself." He continued, "I have found a way of recording it. The subjects were never so near to life . . . never so completely translated to the medium."[10] The more direct contact between object and picture was exhilarating.

Solarization provided Man Ray with another opportunity to bridge the distance between the photograph and the photographer. Once again claiming to have "discovered" the technique in the darkroom when assistant and collaborator Lee Miller "accidentally" turned on the light during the developing process, Man Ray used the process as another way to explore his long fascination with artificial light and with isolating objects to enhance their mystery. In his hands, solarization added expressive prominence to outlined faces and figures, shifting them out

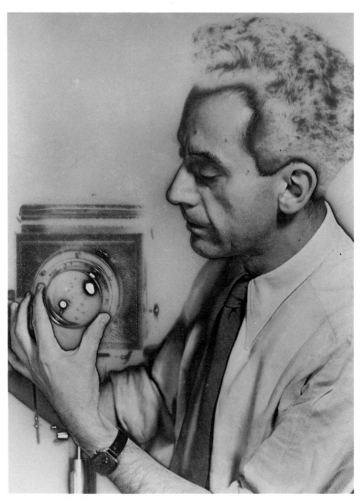

Man Ray, *Self-Portrait*, n.d.

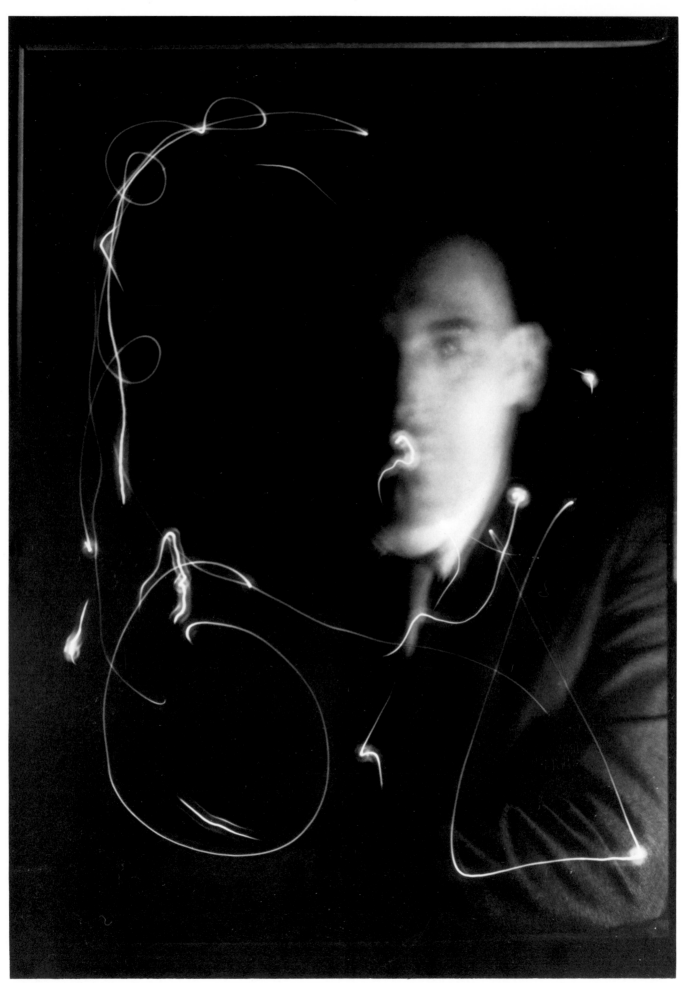

Man Ray, *Space-writing*, n.d.

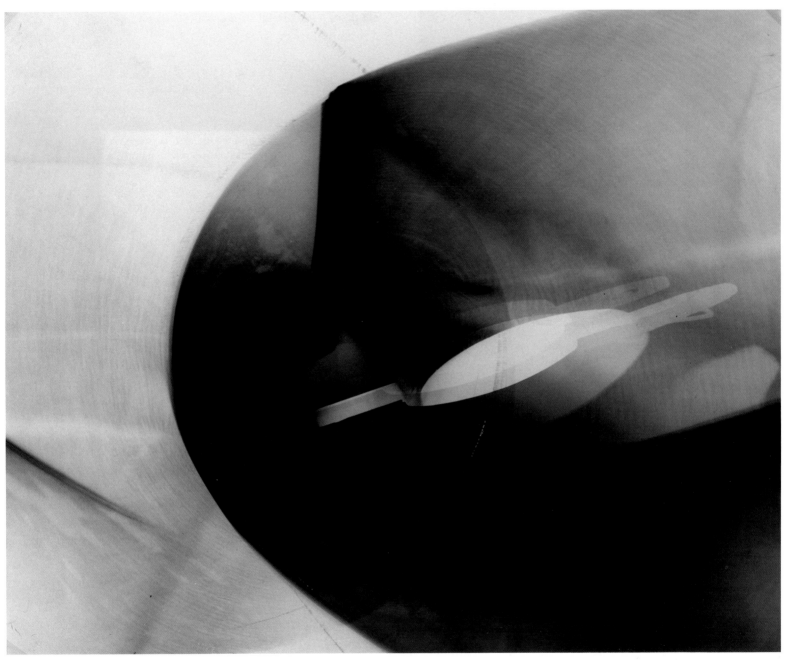

László Moholy-Nagy, *Untitled*, n.d.

of the world of the everyday and into the dream world so beloved of the Surrealists. Solarization also added an exotic flavor to commercial photography. Emphasizing the outline of form, a solarized mannequin more exactly as well as expressively described the line of the costume—the true art of the couturier.

For Moholy, experiments with negative and positive images offered a way of exploring the pictorial meaning of the absence of light as well as its presence. Portraits of women are interrupted by cast shadows, defining radiant halos which both describe form and carry emotional meaning. In his hands, a shadow is as useful for description as a patch of light. When the artist's own shadow controls the picture, falling across the upturned face of a woman lying on a beach, for instance, Moholy is able to join objective description with artistic intervention.

In a century dominated by technological innovations that increase the speed of life, much of the experimentation that occupied photographers during the 1920s and 1930s was concerned with the central problem of conveying artistic imagination in the most immediate way possible. "The touch of the artist," and the aesthetic pretenses that went with it, were replaced by a more appropriate collaboration with materials.

Theodore Roszak, *Untitled*, n.d.

both groups had strict regulations, but, in the peripatetic cafe life that distinguished ideological discourse in Paris, Man Ray thrived.

If "photogenic drawing"—the nineteenth-century term for prints made by placing objects directly on light-sensitive paper—had been around since the invention of photography, in the context of twentieth-century visual experimentation, photograms were heralded as a new art form. Yet, beyond the reference to "*main*," the French word for hand that was also a pun on his name, the frequent appearance of Man Ray's hand in the image harkens back to more basic and ancient artistic gestures. Appearing like scenes from a modern-day Lascaux, Brassai's photographs of graffiti-marked city walls also suggest the most immediate kind of communication. Not only records of a unique pictographic language, as close-cropped descriptions of incised texture and abstract patterns they are evocative of the physicality implicit in the process of graffiti itself.

Less inventor than professor, Moholy was fashioned by the teaching systems of the Bauhaus. While the artistic mix there was as international as that of Paris, the bias was toward a brand of East European pragmatism far more programmatic. At the Bauhaus the formal investigation of shapes and color combinations, as well as the integration of arts and manufacturing processes, had to be turned into real pictures. Under director and architect Walter Gropius, the Bauhaus offered a more disciplined version of art and science than the imaginative explorations of psychology practiced in Paris.

In his foundation course at the Bauhaus Moholy did not teach photography as such, but simply taught his students the medium and had them make photographs to liberate their minds from convention. In America, Theodore Roszak, who worked with Moholy in Chicago, reinforced the Constructivist aesthetic of his sculptures with the inventiveness of photograms. Liberated from materials—save paper and developing tray—he could start with an arrangement of perfect balance, disturb it, and then restore it to a new equilibrium. Perhaps Moholy enjoyed the story of the discovery of the X-ray—the inspiration for his own photograms—which Wilhelm Roentgen had found by accident while looking for something else.

Man Ray's 1933 drawing *l'Enregistrement d'un rêve* (The recording of a dream) offers a Rube Goldberg image of the workings of the imagination—and of photography. Close to her upturned face, a model holds a fanciful camera whose lens doubles as an illuminating reflector. Thus framed, the model's profile is fixed, almost etched, onto the paper, while the camera absorbs not only the model's portrait but her state of mind into a bag marked *air sensibilisé* (sensitized air). Or perhaps the direction is reversed and it is the artist—via the camera—who "sensitizes" his subject. All this takes place against the studio backdrop of the *écran transparent* (transparent screen), an object that suggests the permeability of the photographic image.

When Moholy traced the abstract pattern of loops from the

Imagination was seen as the essential element in any artwork— the quality of sensation that Robert McAlmon, in naming the experimental 1920s literary journal *Contact*, had equated with "that instant of an airplane touching ground."

During this period, what art was and how it would look—and above all how to create a machine-age art capable of sincerity— were continual questions. Man Ray, always the practical American, had become a key player during a period of post-dada reconstruction. While the dadaists had determined that "art for art's sake" was no longer possible, the group could not agree on alternatives. Rayography offered one solution: it was a visual translation of André Breton's Surrealist poetics, as well as a vulgarization of traditional painting *and* traditional photography in keeping with Tristan Tzara's dada revolution. To be sure,

Man Ray, *Untitled*, n.d.

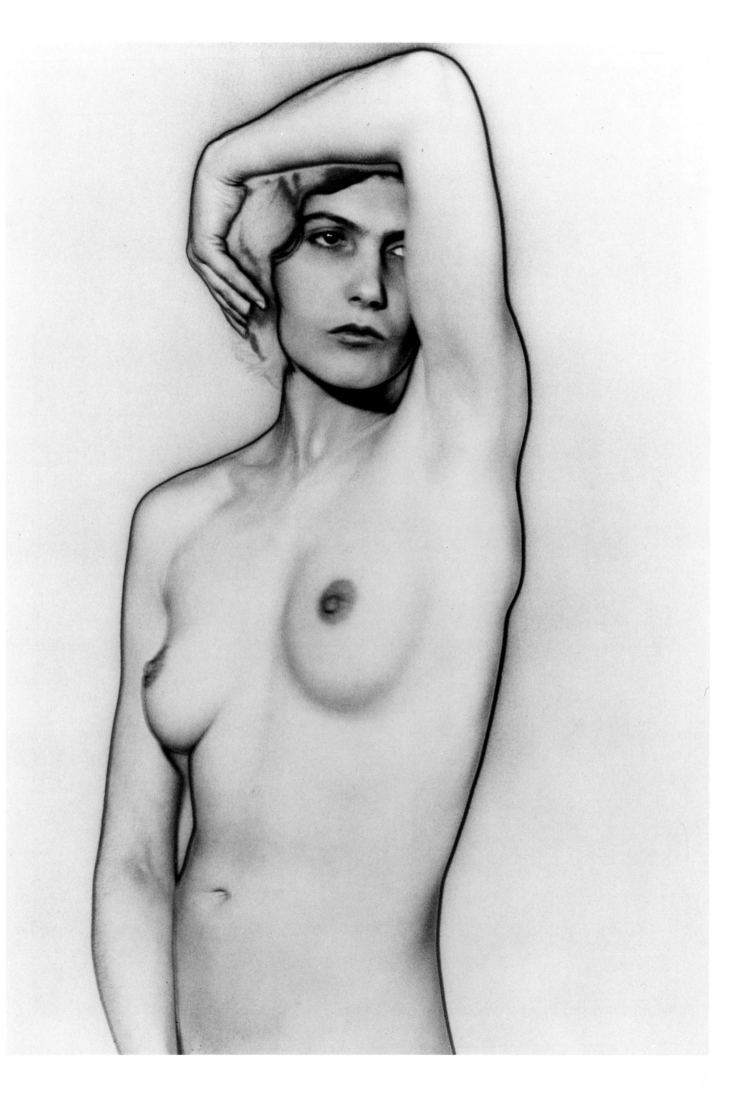

László Moholy-Nagy, *Untitled* (looking down from the Radio Tower, Berlin), c. 1928

photograph of the parking lot he accomplished more than simply demonstrating the principles of originality and reproduction. Ceding its existence to the photographic image, the drawing copied what was inherently linear in the photograph. In photographing his studio performance to make his light drawings, Man Ray returned gestural immediacy to the mechanical rendering of photography. In this way he reasserted his own control as artist over the image, reclaiming it from the supposedly rigid demands of the camera.

For these artists it was not the photograph, the drawing, or the question of which came first that was important, but the subversion of traditional systems of rendering. Through the

"Drawing with light," using "light in place of pigment" were phrases Moholy used to describe his initial efforts in photography, experiments that preceded the photographs he made with a camera.

experiments of the avant garde, boundaries between media had become thoroughly blurred. All tools and methods were available to artists in their search for new ideas appropriate to the new age.

Even Picasso—the artist Man Ray said was capable of executing the "single most beautiful line"—occasionally traced photographs in making his drawings. In 1919, at a time when he was attempting to forge a rapprochement between Cubism and classicism, Picasso produced a number of drawings based on photographs.[11] Transferred from publicity photos or lifted from photo-postcards, dancers from the *Ballet russes* or Italian peasants are reduced to the outlines of their photographic forms. Framed by contemporary debates over abstraction and realism, artists searching for new forms compounded media in similar ways, posing deep challenges to conventional assumptions about the appropriate relationship among media.

For Moholy, Man Ray, and others, photography was a medium ripe for experiment and discovery. These artists believed in the untapped pictorial possibilities to be found in familiar materials. However, they did not hold that photographs could or should mimic other media—in the words of one critic, "so that they will look like a drawing by a second-rate academician." Instead they argued that they could describe new states of artistic consciousness.[12] Making contact, providing a way to link the thrilling accident of discovery with the technical means of reproduction, photography was seen as something other than an artistic medium in the usual sense. In the hands of these artists, quality of line, that spontaneous combination of emotional content and artistic presence, was reclaimed for photography. And photography, in its turn, was acknowledged—in a way it had not been since its earliest days—as a pictorial medium capable not only of recording events in the world, but of invention, transformation, and prediction. □

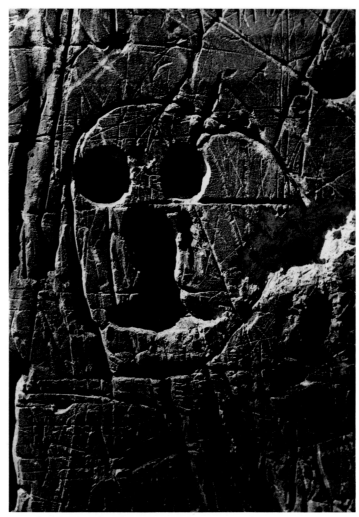

Brassai, *Tête de mort* (Head of death), c. 1950

1 For a complete discussion of this period see *The New Vision: Photography Between the World Wars*, Maria Morris Hambourg and Christopher Phillips, New York: The Metropolitan Museum of Art and Harry N. Abrams, Inc., 1989. 2 "New Photography Employs No Lens," *New York Times*, Sunday, January 6, 1924. Man Ray had come to New York to attend the opening of his 1923 film *Emak Bakia* at the Film Arts Guild of New York. It was his only visit to the U.S. between 1921 and 1940. Moholy-Nagy paid his first visit to the U.S. in 1937. 3 Man Ray, *Les Mains libres*. With poems by Paul Eluard. Paris: Editions Jeanne Bucher, 1937. 4 It cannot be established for certain whether Moholy knew of Man Ray's earlier photographs or rayograms, or Christian Schad's even earlier works. The photogram, worked on by Man Ray, Moholy-Nagy, El Lissitzky, and others, was a well-known genre of an avant-garde period. 5 Moholy-Nagy quoted by Otto Steilzer, in postscript to Moholy's essay, "Painting Photography Film," 1967. As cited in *Man Ray: American Artist*, Neil Baldwin, New York: Clarkson N. Potter, 1988, p. 98. 6 Ibid. 7 "Manifesto of Elemental Art," signed by Raoul Hausmann, Hans Arp, Ivan Puni, and László Moholy-Nagy, Berlin, October 1921. Reproduced in *Photographs & Photograms Moholy-Nagy*, Andreas Haus. New York: Pantheon Books, 1980, p. 46. 8 Moholy-Nagy, "Photography is Manipulation of Light," Printed in *Bauhaus* No. 1, 1928, pp. 2ff. Reprinted in *Photographs & Photograms Moholy-Nagy*, Andreas Haus. 9 Moholy-Nagy, "Produktion-Reproduktion," *De Stijl* (Leiden) 5, no. 7 (July 1922). Reprinted in *Photography in the Modern Era: European Documents and Critical Writings, 1913-1940*. Edited by Christopher Phillips. New York: The Metropolitan Museum of Art and Aperture, 1989. pp. 79-82. 10 Man Ray to Ferdinand Howald, April 5, 1922. Man Ray-Howald Correspondence, Library for Communication and Graphic Arts, The Ohio State University, Columbus, Ohio. 11 See *Pablo Picasso: A Retrospective*, edited by William Rubin. New York: The Museum of Modern Art, 1980. pp. 199-218. 12 Lewis Mumford, "The Art Galleries: Critics and Cameras." *The New Yorker* 10, no. 33 (29 September 1934) p. 35. Mumford was reviewing *Photographs Man Ray 1920 Paris 1934* published by James Thrall Soby, Hartford, Conn., 1934.

Conservation of Matter:
Robert Rauschenberg's Art of Acceptance

By Donald J. Saff

I use photography—use everything that I can find—but photography is a way for me to stay in touch with all the shadows and highlights that are around me. It's an exercise that keeps my feet on the ground but moving, the realization that every corner of the room is never going to be the same again.—Robert Rauschenberg

As the felt need for art precedes its making, so does the act of making art precede the development of theoretical formulations about it. This is particularly true in the case of Robert Rauschenberg. For him, as for poet Robert Frost, the way to artistic accomplishment has led him to roads less traveled by his contemporaries.

Along those roads, Rauschenberg was influenced by a variety of formal and informal contacts with the world of art. After studying briefly at the Kansas City Art Institute, he moved to Paris in 1948 where he enrolled for classes at the Academie Julian and the Grand Chaumiere. In Paris he visited museums where he first saw the works of Matisse and Picasso. He spent time painting in the streets and also met Susan Weil, a fellow student and artist whom he later married.

After reading an article in *Time* magazine about experiments in art that were being carried out at Black Mountain College in North Carolina, Rauschenberg decided that he might find there an environment more responsive to his needs. Accordingly, Rauschenberg and Weil left France for North Carolina in late 1948.

At that time Black Mountain was the place to be if one wanted to witness and take part in innovation in the arts. Among the college's faculty and visitors were such art-world luminaries as Franz Kline, Willem de Kooning, Walter Gropius, John Cage, Merce Cunningham, and Josef Albers. At Black Mountain,

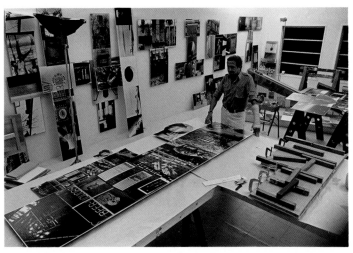

Robert Rauschenberg working on "Photems" in the Captiva Studio, 1981

Rauschenberg was exposed to people and ideas that deeply affected his life and his art. His work with Hazel Larsen, about whom Rauschenberg always speaks with great fondness, inspired his love and respect for photography. Lectures by Irving Penn, Harry Callahan, and Aaron Siskind further strengthened Larsen's influence.

Working with Albers intensified his ability to see the entire visual world and to embrace it as his own. Indeed, Rauschenberg's passion for color, his love of visual and tactile properties

> *Rauschenberg draws no distinctions between positive images on photographic prints and imagery as it appears on the negative. He uses both in much of his art, and often leaves the viewer in doubt as to which is which.*

of a wide variety of materials, and his respect for ordinary objects were heightened by his work with Albers—although often because of Rauschenberg's resistance to Albers's Bauhausian restrictions. Moreover, he learned that intensive work and personal discipline are essential to artistic development.

Being at Black Mountain also involved taking an active role in the community of artists, both faculty and students, in residence there. Collaboration among the residents was essential to the realization of various student projects, and Rauschenberg often was called on to participate in joint works. No matter what was required—a painting, a stage set, costumes, lighting, choreography, a performance, or ideas—Rauschenberg gave freely of his time, energy, and talent. Later he would explain, "I didn't want anyone to stop creating something, or to fail in something, because of selfishness on my part."

For several years after his first semester at Black Mountain, Rauschenberg divided his time between New York and North Carolina. Studies at the Art Students League in New York and periodic residencies at Black Mountain offered him the opportunity to further develop what would become long-time relationships with composer John Cage, choreographer Merce Cunningham, and pianist David Tudor, among others.

In New York, he often took part in the weekly discussions about contemporary art held at the Artists' Club, and was a more frequent participant in evening sessions at the Cedar Bar, a favorite watering hole for "older" Abstract Expressionist painters such as de Kooning, Kline, Mark Rothko, and Jackson Pollock. It was there that he often met with Siskind; it was there, too, that the devils of conformity and tradition were cast out nightly by rites of exorcism marked by much drinking and good conversation. Rauschenberg often was accompanied on these

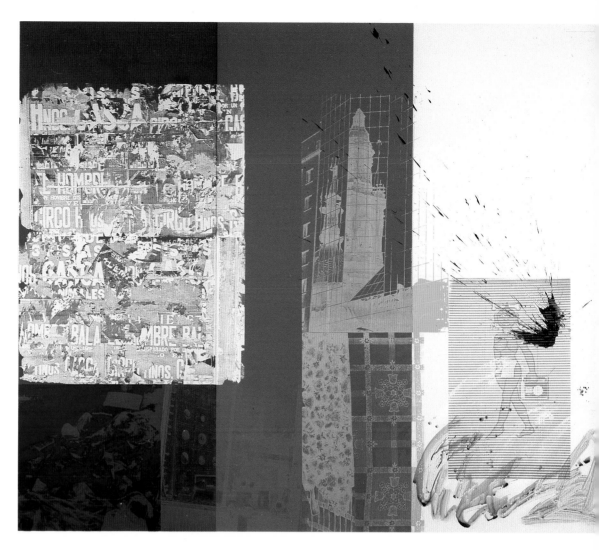

Robert Rauschenberg, (right)
Continental Splash, 1989

(below) *Level Revel/ROCI USA
(Wax Fire Works)*, 1990

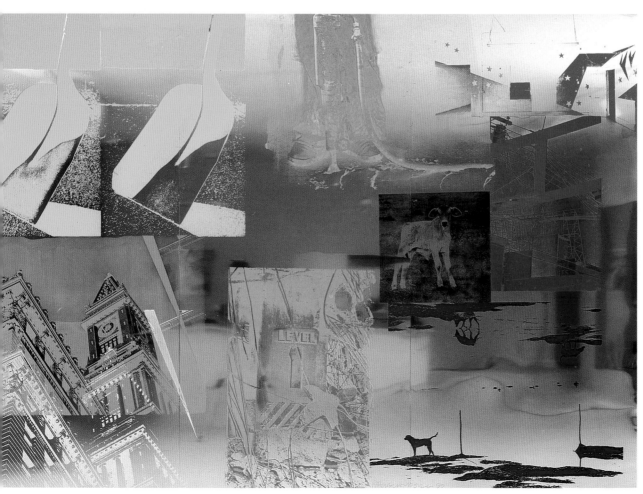

I'm a regular community when I go to work; television,
assistants, dogs, friends are all part of what's going on. I've always
wanted my work to look more like what was going on outside the
window than in the studio. Having all this activity going on
is one way of bringing the outside in. I like to think
that my work in material and in visualization is filled with
natural events, and this kind of activity helps you stay
pretty much in tune with what's going on around you.
It serves as a way of my not getting a fixed idea
about direction and intention in the work in progress.
—ROBERT RAUSCHENBERG

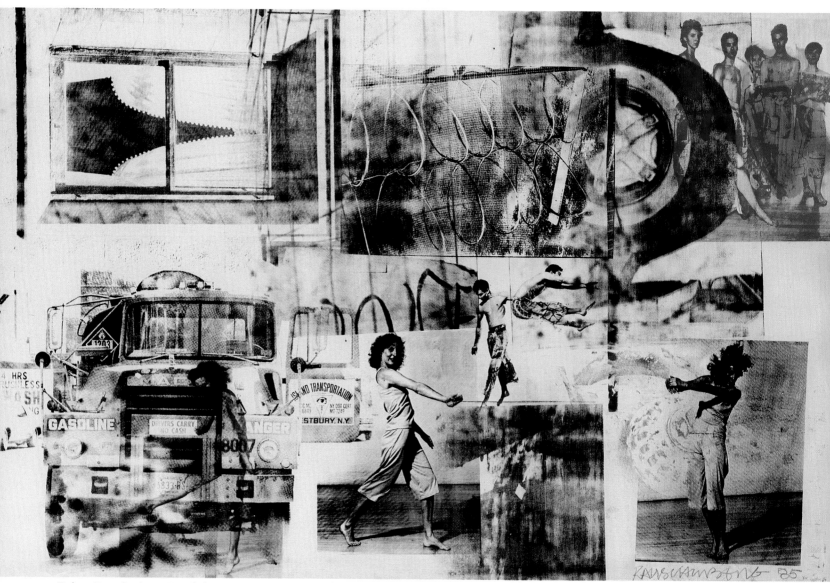

Robert Rauschenberg, *Untitled*, 1985

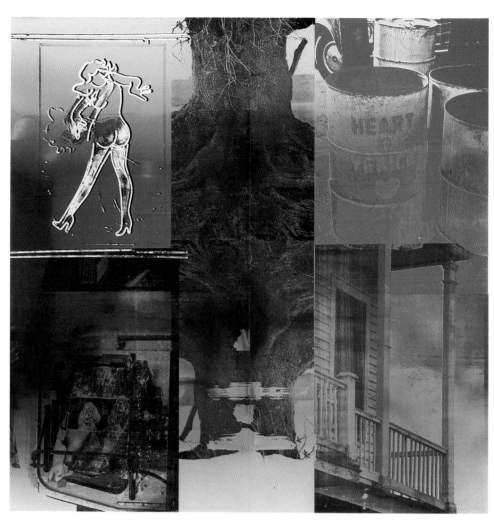

Robert Rauschenberg, (right) *Daphne/ROCI USA (Wax Fire Works)*, 1990

(below) *Bus Stop Fantasy*, 1989

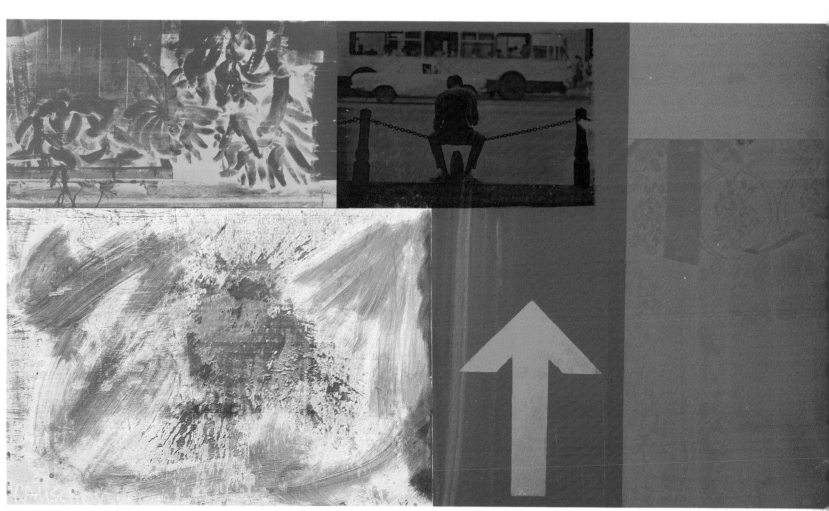

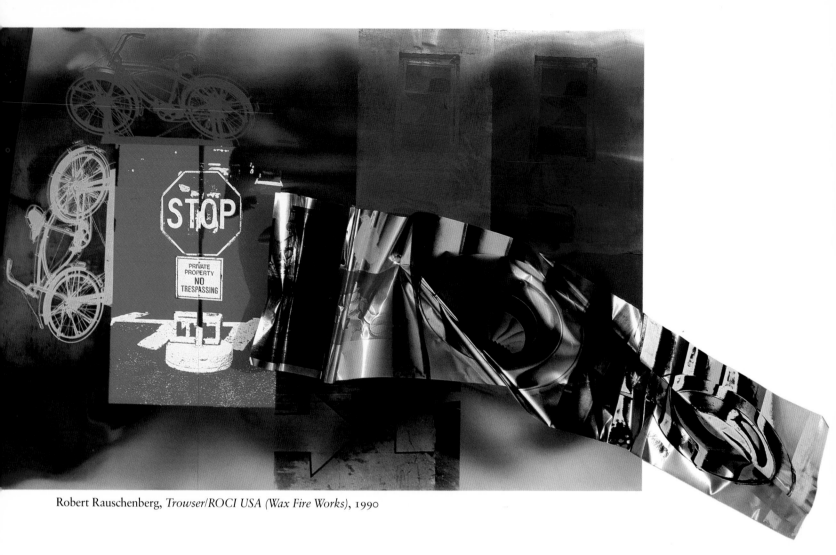

Robert Rauschenberg, *Trowser/ROCI USA (Wax Fire Works)*, 1990

forays by his close friends and fellow artists Cunningham, Cage, and Jasper Johns.

He admired certain qualities in the work of the Abstract Expressionists, but his artistic bent was of another kind. His experiences at Black Mountain and his friendship with Cage had been instrumental in helping him to develop an approach to art that had never before been fully explored. While Cage's position flowed in part from a deep interest in Zen Buddhism, Rauschenberg's insights were in large part natural extensions of instinct, feeling, and intuition. These glimpses of profound realities would later be fleshed out in more formalized ways. Rauschenberg was particularly influenced by the *I Ching*. The ancient Chinese understood the role of intuition and chance in the unfolding of psychic and physical events, ideas that have only recently become central themes in psychology, physics, and mathematics.

Like the ancient view that nature creates all things without erring, and in its greatness accepts all things equally, Rauschenberg's universe acknowledges no arbitrarily established hierarchical system of values. Thus, in his work, Rauschenberg attempts to reveal what the *I Ching* describes as the natural ties among all things cosmic and temporal. He undertakes this through a process of actualization of form that continues until everything is realized in its true nature, in conformity with the harmony of the universe. In Rauschenberg's mind, the products of such a process require equal respect, and his art permits all things to present themselves with equal dignity.

Unlike the Abstract Expressionists, whose art emphasized the individuality of the artist's personality and gestures in the act of making art, Rauschenberg believed that evidence of the artist's prejudices and process had little place in a work of art. This allows whatever is in the work to be perceived on its own terms, unaltered by the artist's personal view of what it should be.

At every step of his work, Rauschenberg is on guard against any act that might betray a personal prejudice that could find its way into his art. His studio is a dynamic arena, with one or more television sets operating and people engaged in a variety of activities. Of his studio life, Rauschenberg says,

I can't be there without the television on and my studio assistants screaming at me. I'm a regular community when I go to work; television, assistants, dogs, friends are all part of what's going on. I've always wanted my work to look more like what was going on outside the window than in the studio. Having all this activity going on is one way of bringing the outside in. I like to think that my work in material and in visualization is filled with natural events, and this kind of activity helps you stay pretty much in tune with what's going on around you. You don't have time, or reason, to decide that some things are important and others

aren't. Also, this activity serves as a way of my not getting a fixed idea about direction and intention in the work in progress.

Although Rauschenberg is best known as a painter, photography has played an important role in virtually all aspects of his art. In the earliest days of his development as an artist, he considered pursuing photography full-time. Hazel Larsen urged him to meet Edward Steichen, who upon seeing his photographs said, "Looks like Black Mountain quality." In fact, Rauschenberg's first sale as an artist came in 1952 when Steichen acquired two of his black-and-white photographs for New York's Museum of Modern Art, at a price of $15 each. "But I decided I knew less about painting than I did about photography," Rauschenberg recalls, "so I decided to do what I knew less about and continued my focus on painting. Later I discovered that photography and painting were the same thing."

This decision to devote himself to painting was made easier when he overwhelmed himself with the idea of a photographic project that would involve walking across the entire United States, photographing it foot by foot, in actual scale. (When I asked Rauschenberg recently if he really wished to show everyone everything, he answered yes.) The thought of the full-time dedication this interminable project would require was sobering, and Rauschenberg turned his attention to painting. However, he continued to work with photography, and as his painting progressed he made increasing use of photographs in his work. At first he sometimes relied on the images of others, but in recent years he has used his own photographs almost exclusively.

He continues to use the camera to collect information about the world, document his experiences, and provide a means for making art. Beyond this, the camera's demands provide a continuing challenge and help keep his eye sharp. "Although I am primarily a painter, I have never stopped being a photographer," Rauschenberg is quick to point out.

"Insofar as one paints, one draws," Cézanne remarked. Today, we can say with equal confidence that to the extent that one manipulates any material in the process of realizing artistic form, one draws. Thus, it is in the context of a deeper understanding of Rauschenberg's approach to the making of art that traditional concepts of photography and drawing lose their power to define or inform; in the end, they must yield to an appreciation that can be found only in experience.

The iconoclastic implications of Rauschenberg's approach to art were clear from the beginning. Between 1949 and 1951, in collaboration with his then wife, Susan Weil, he produced the first of a series of blueprint works, consisting of images produced by the effects of a sunlamp shining on objects or bodies stretched out on large sheets of blueprint paper. For Rauschenberg, the results demonstrated that the interaction of materials and processes helps shape the outcome of any artistic action.

By 1951 Rauschenberg was also involved in making his *White Paintings*, in which ordinary house paint was applied to the

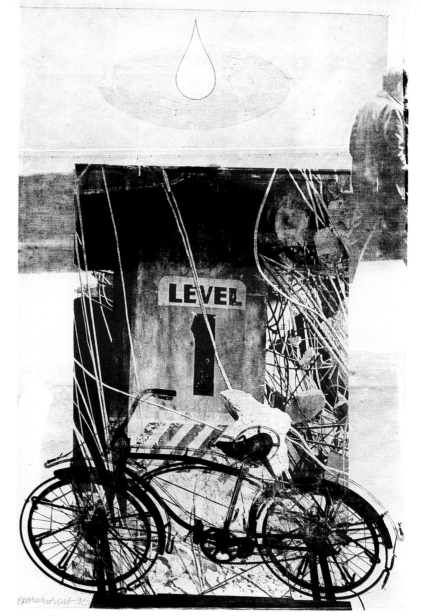

Robert Rauschenberg, *Drop*, 1990

canvas with a roller. The first New York exhibition of these paintings, at the Stable Gallery in 1953, also included the more elaborate and textural *Black Paintings*, which Rauschenberg had recently completed. "I didn't want the *White Paintings* to make people think that nothing could be dark," Rauschenberg said of the *Black Paintings*. Cage likened the *White Paintings* to "airports for lights, shadows, and particles." For his part, Rauschenberg was interested in exploring a reductive process, "to see how much you could pull away from an image and still have an image." He would later observe that one could almost tell the time of day or count the people in the room according to the changing patterns of light and shadow cast on the surface at any given moment. His remarks could have the same application to images on light-sensitive photo paper or his later work on reflective metal surfaces.

Response to this first formal presentation of the *White* and *Black Paintings* ranged from outrage to dismissal. Few saw possibilities for their development, fearing that Rauschenberg had left himself no place to go. In retrospect, the *White Paintings* were anything but an end. Rather, like the cosmos before the

big bang, they contained nothing and everything. Since then Rauschenberg's art has taken on many different incarnations, appearing in ever-changing permutations of technologies, materials, images, and ideas.

Rauschenberg's now-famous *Erased de Kooning Drawing*, 1953, stands as a benchmark in the development of his art. For some time, he had been using the eraser as a drawing tool. In his drawing studies at Black Mountain Albers had forbidden the use of erasers, and to some extent Rauschenberg's experiments in "drawing with an eraser" helped purge him of the limitations imposed by Albers's prohibitions. Realizing that erasing his own art would "return to nothing," he required a work already recognized as art to demonstrate the new possibilities of what he called a "monochrome no-image." After convincing de Kooning to contribute an important work to the project—de Kooning selected a drawing that was extremely dense, making the task more formidable—Rauschenberg spent several weeks and used

up numerous erasers obliterating the drawing. The result was a collaboration with de Kooning, rendering a piece of his work no longer visible.

Rauschenberg experimented with the application of light on blueprint paper and drew with bleach on Polaroid prints, recalling the *Erased de Kooning Drawing*, in the partial image-removal series, *Bleachers*, 1988–90. He also incorporated X-rays into his constructions (as in *Booster*, 1967), and has refused to accept size limitations for his photographs. He has produced works ranging from direct contact prints to the monumental *Chinese Summerhall*, 1982, which presented photographs he had made in China on a single sheet of photographic paper measuring thirty inches by one hundred feet.

Light and shadow used to define visual form are critical elements in Rauschenberg's photography. He draws no distinctions between positive images on photographic prints and imagery as it appears on the negative. He uses both in much of his art,

Robert Rauschenberg, *A Doodle (Borealis)*, 1990

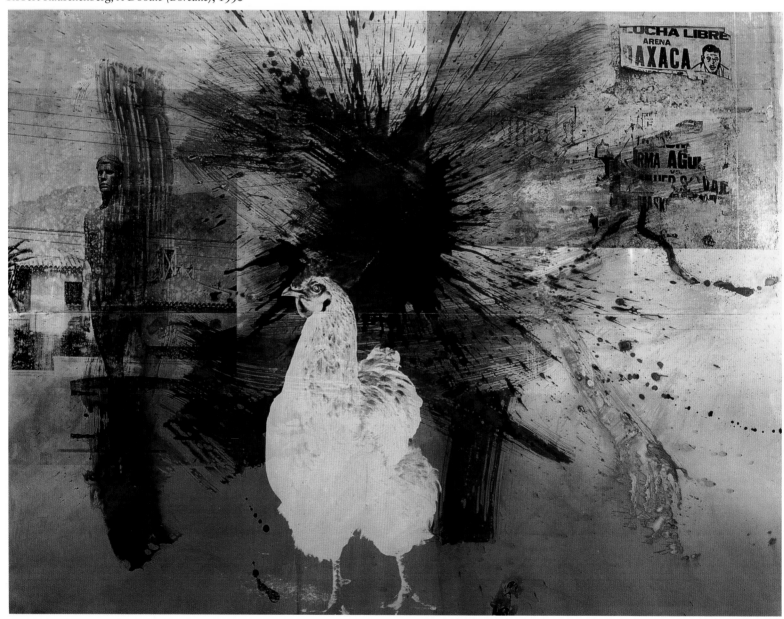

and often leaves the viewer in doubt as to which is which. For Rauschenberg, there is no positive and negative in the world—only things in process.

There are also few effects in his art to indicate visual perspective. This is in keeping with his desire to allow all things to come

He continues to use the camera to collect information about the world, document his experiences, and provide a means for making art. "Although I am primarily a painter, I have never stopped being a photographer," Rauschenberg is quick to point out.

to the surface with an equal opportunity to be seen for what they are. Perspective, by its nature, implies a hierarchy in the importance of things, by virtue of their relative size and location in space. As such, perspectival depiction runs counter to Rauschenberg's attitude, which refuses to establish a value system that places one thing ahead of another arbitrarily.

Likewise, in Rauschenberg's art, the principles governing the conservation of matter in the physical world are matched by a similar set of principles governing the conservation of aesthetic energy and the convertibility of artistic forms from one state to another. His images are not confined to a single realization, but appear and reappear in a variety of contexts, each of which may lead to a subsequent appearance in another place and another time, for another reason.

For some people Rauschenberg's photographs can provide a bridge between the real world and the world presented in his paintings and sculpture. When the artist met with Chinese students in Beijing in 1982, their initial responses reflected confusion and lack of understanding about the man and his art. But for the Chinese, as for most people, photographs carry a higher "truth" value than imagery in other media. When the Chinese saw Rauschenberg's photographs, they recognized this truth value. The images connected the viewers with the reality of their daily lives in a way that was convincing and profound. Later, when they discovered these images appearing in the paintings and sculpture, the "truth" found earlier in the photographs was transferred to the larger works in ways that provided an understanding of Rauschenberg's art.

Rauschenberg is well known for reclaiming objects discarded by others, and giving them new life as part of his works. In the same spirit, many images realized in one way in his photographs are not cast away, but are given an opportunity for other lives. A case in point is the bicycle image prominent in Rauschenberg's *Trowser/ROCI USA (Wax Fire Works)*, 1990, shown in the recent Rauschenberg Overseas Culture Interchange (ROCI) exhibition at the National Gallery of Art in Washington, D.C. Rauschenberg first saw the bicycle as a neon sign outside a shop in Charleston, South Carolina, and photographed it. The photo-

graph in turn appeared in *Drop*, a 1990 work in acrylic on fabric-laminated paper. It then was utilized in *Trowser*, printed in fire wax on aluminum, and is also referred to in the sculpture *Rocket/ROCI USA*, in which a bicycle is outlined in neon—much like the original Charleston sign.

At the National Gallery, *Trowser* took on an additional dimension, as people, objects, and light from inside and outside the gallery were reflected in its mirrored surfaces. The bicycle sculpture, *Rocket*, was also reflected on the glass wall of the gallery, and seemed to be levitating in the Japanese rock garden beyond. The reflection of *Rocket* captured Rauschenberg's attention anew, and was photographed for yet another incarnation, in accordance with Rauschenberg's "conservation of matter" methodology.

Sequences such as these exemplify Rauschenberg's working method. In other pieces he has reversed the procedure by first photographing works of art, as in *Classic Cattleman Counter Column (Late Kabel American Zephyr)*, 1983, which appears as both negative and positive images in *Orphic Ditty (Salvage Series)*, 1984. As with sinopia underdrawings and their fresco counterparts in the thirteenth and fourteenth centuries, the image is the same, but the various realizations offer very different experiences. The processes of renewal, change, and conservation exemplified by the transformations these images undergo have been central to Rauschenberg's work throughout his career.

Rauschenberg does not crop his photographs. "It's because I have the patience to wait until life unfolds in the frame. . . . When an image containing the essence of life is concentrated in a way that reflects real life and facilitates your recognition of it, you have proper permission to take your picture." He has likened the process of taking pictures to that of a diamond cutter: "If you miss, you miss," he says philosophically. The same is true for his painting. "If you don't cut, you have to accept the whole image," and acceptance is his guiding principle.

The care Rauschenberg takes with material, images, and form in his art are reflections of the care he feels for all that lives. His concern for people and desire for peace found expression in his recently completed world tour of the Rauschenberg Overseas Culture Interchange. Believing in the power of art to create conditions hospitable to peace, he spent much of the last eight years traveling the globe, sharing ideas with artists and creating and exhibiting a body of art reflective of the cultures he experienced along the way.

The principles that guide Rauschenberg's art also guide his life; in fact, he sees no distinction between the two. "I am, in a way, a mirror for the world," he says. Implicit in that statement is Rauschenberg's attempt to help introduce the world to itself. His work on the ROCI tour was an effort to further a spirit of unity and an attitude about peace that can emerge when we learn to celebrate together the things that make us different from one another. "I make my art in a way that leaves its meaning to be discovered by the viewer," he says. "If any two viewers see the same thing, then perhaps I have failed in my work." □

Into a World of Color: An Interview with David Hockney

By Graham Nash

Graham Nash: I think we come from similar places in England, similar backgrounds. I'm from Manchester. And you're from Bradford?

David Hockney: Yes, I was born there in 1937.

GN: My main impression of the north of England was that it was very gray, monotone. My question is, how do you get your incredible sense of color? Is it a backlash against the grayness of your youth?

DH: Well, first of all, I don't know what my color sense really is, but it's true that my childhood was spent in Bradford, which was then extremely black. I mean the buildings were absolutely covered with soot.

GN: Coal dust.

DH: Everything, coal dust and soot. Deep into the stone. And it rained a great deal, so you'd get these gray reflections. The only color you saw was if you left the city, and then it was extremely green, this rich green. But you still didn't see color, because in those days you didn't even see red cars or anything. I was at Bradford Grammar School, where the uniform was a brown blazer. It was the only thing that wasn't gray—it was shit brown instead.

When I first looked at van Gogh's paintings, I used to think everything was exaggerated because the world I knew didn't look like that. Van Gogh was northern, from a climate that was probably very similar to Bradford's. And probably fairly colorless, especially in the nineteenth century. He wanted to go to the south because he thought there was more joy there, more color. I feel that too.

GN: Is that why you came to Los Angeles?

DH: Oh, yes.

GN: Did you find that your sense of color changed? I came here in 1968 from the north of England, and I flowered.

DH: Yes, yes. The moment I came to Los Angeles I loved it instantly. I thought, this is the place for me. I didn't know anybody, and I didn't have much money,

either. I had enough money to learn to drive within a week, and I bought a car and lived in it. It was a silver-gray Ford Falcon, about five years old. It had done 32,000 miles and I put another 50,000 miles on it in a year. I drove everywhere in it. I was always driving out of L.A., into the desert—anywhere. I loved it.

GN: Did you feel that you'd escaped? When I came here I had this great sense of escape.

DH: Well, I got out. But my parents never expected me to stay in Bradford, nor had they expected me to do what my father did. In fact, my parents were extremely naive about what I was doing.

GN: What kind of photographs did your dad take? I think we have another great correlation here. A traumatic thing happened in my life. My father was an amateur photographer, and once bought a camera from a friend of his at work for thirty bucks. We'd go to the zoo and I'd take pictures and he'd take pictures, and then he'd put my blanket over the window of my bedroom and use it as a darkroom. Then one day the police came. What had happened was that my father inadvertently had bought a stolen camera. So he went to jail for a year, because he wouldn't say who he'd got it from, because he wouldn't grass on his fellow worker.

DH: What year was that?

GN: I was eleven, so that would have been '53. There's a viciousness to that country.

DH: Yes. I know that side of it. I know it well.

GN: What kind of pictures did your dad take? Do you remember? Did he make a living as a photographer?

DH: No, no. He was a civil servant. When he retired he wasn't earning a thousand pounds a year. He never earned more than a thousand pounds in his life.

GN: I don't think mine did, either.

DH: On the other hand, we never really felt poor. We just didn't do things other people did, that's all. We did them another way. It never bothered us. But he took photographs all the time, He was deeply interested in taking photographs, but, of course, when I was very young, he couldn't do many. You remember, during the war you couldn't buy film.

GN: Of course not.

[Still video] did make me see how I might use color in a different way. It's not coming out of the chemical process of film itself, but the mechanical and electronic process of the printing medium. Maybe this is the end of chemicals and water in photography.

DH: Things were very scarce. Even after the war, it was a while before you could readily buy film. And it was all black and white. That's what I have against black-and-white photography. I see it as perpetrating grayness. For good black-and-white photography you need sun, some contrast. In Bradford it was all dim light and grayness.

GN: Was your dad thrilled when your photographs became successful?

DH: Oh, yes. I guess so.

GN: I remember about eight months before my mother died, I asked her, "Why did you encourage me when I was kid, thirteen, fourteen years old?" My friends who wanted to play guitar and sing in pop groups and stuff, their parents were telling them to get a real job—go work at a mill. My mother and father never did that. They always encouraged me. I always wondered why. Why were they different?

And my mother, eight months before she died, told me she'd wanted to be on the stage herself but because it was after World War II and she'd had kids, she couldn't.

DH: I must point out, the English working class is clearly divided into two sections. There is a deeply conservative section and there's a radical section. I come from the radical section.

GN: Yes, so do I. Have you ever combined painting or drawing with photography—drawn on photographs, or used photographs in paintings or drawings?

DH: Not really. In fact, when I say that the two media are starting to come together—

GN: —you don't mean physically.

DH: No. I mean that the computer allows us to work on a photograph the way a draftsman might—somebody who knows how to draw, who knows how to move things around and change the sense

of space and so on. What's happening is that this is becoming common in computer-generated photography. Advertisers are using computers a great deal, seamlessly superimposing images. In fact, I'm very aware of this now. I watch *Who Framed Roger Rabbit* all the time. It's a great masterpiece.

GN: Yes, it is.

DH: The computer wasn't just helping them with the animation. I realized they were using a device that I use myself, a computer device that softens the edge of a line. This means that the drawn Roger Rabbit is seen within the perspective of the image, making it seem like it's part of the same space as the rest of the picture. There's no harsh line between him and any other space. The computer has taken that away.

GN: That's a drawing skill.

DH: Yes, it is. You can begin to see how drawing skills, used with the computer, can extend photography into different spheres. As a result, I think you can make different pictures.

In a sense, I think we've lived in a black-and-white world for too long—and photography has had a great deal to do with it.

I'll tell you something else about photography. I recently saw a show of Constable's paintings in London—a fabulous show. I have three books on Constable here. If you compare how one single painting is reproduced three different ways, you'll see that printing is not at all a purely mechanical process. The color varies in each. I've noticed that whenever mechanical reproduction is involved, love of the painting or image will always make it better. I'm also making another point. When Woody Allen went to Congress and argued against colorizing black-and-white films, I thought it was a stupid argument. That was the argument of a conservator, not an artist. I thought it was like telling my father not to sprinkle a bit of Day-Glo glitter on his cards at Christmas. He wanted to touch them up—any artist would want to.

In a sense, I think we've lived in a black-and-white world for too long—and photography has had a great deal to

David Hockney, *Margaret Hockney and Ken Wathey, #1*, December 26, 1990

do with it. I know it produced these lovely rich tones, but those lovely rich gray tones of Bradford in 1948 you can keep. I'd rather have the color.

GN: Is there a great difference in the color you see in the world as opposed to the digital color you see on the screen?

DH: Yes, but there's no such thing as true color. With my pictures, results are always different, depending on the printing process. What I want to do is take one of these computer drawings and have it printed various ways—here in the studio, on a different machine, on a commercial printing machine, and so forth. Let's see what each one does to them. The print remains the essential thing; it's still how the image is conveyed. The piece of paper is going to be with us for a long, long time. The computer people haven't seen that far yet. It's the printing machine that matters most. In the end, the thing on the glass doesn't matter. The real question is, how do you translate that, where now do you put it?

GN: How do you deal with the light coming through the computer screen and translate that to a piece of paper, which is reflected light? It's very different.

DH: Of course they're different. That's what I'm saying to these computer people. For instance, look at this red here. [Hockney shows a handmade book he has made up of Canon laser prints.] You can see how heavily layered that is. No commercial printing process could do this—they'd have to print twice. It's easy to keep colors pure on the computer.

GN: You printed these on your Canon, and then shot them for the book?

DH: No, no, these are the actual prints. It's an original drawing, really. I could demonstrate one, just to do it and print it off. And you'll see what I mean, in the sense that you're drawing.

The one thing is, I'm getting a little bit eye-tired. And I think it's this computer. This drawing took me nine hours, maybe. I would draw and print many times over—the reds, for instance, tend to merge together. So I print, look at it, then go back and put a different layer on it. You can get an incredible range of textures that makes the eye run around. We learn every day from this process—it's fascinating—and we have to find out how

David Hockney, *Stephanie Barron, II, #1,* September 6, 1990

to relate to it on new terms. As I say, with the computer you learn there's no such thing as true color. You give up on that.

GN: Photography is getting further from the truth, isn't it?

DH: I thought the Gulf War finished it off, in a sense. It was perfectly clear by the end of the second day that they did not want any images of the war in your living room.

GN: They learned that lesson from Vietnam.

DH: Frankly, it finished television off for me. Now I never bother watching it. I think what we saw with the Gulf War was the end of television as a truthful medium. That's what it meant for me. You'll never believe a TV war again. It's ruined. People are aware of how they are being manipulated because they all own their own video cameras. They've learned a little bit about what's behind the camera.

GN: You've been using a still video camera to make these recent portraits.

DH: It did make me see how I might use color in a different way. It's not coming out of the chemical process of film itself, but the mechanical and electronic process of the printing medium. Maybe this is the end of chemicals and water in photography.

GN: This was one of my great motivations in setting up Nash Editions as an ecologically safe way of producing images, which is in fact far superior to the chemical process, because it's digital technology.

DH: I think we are moving into a more electronic age, there's no doubt about it. In a way, storing information digitally is storing abstractions. I find that quite fascinating, as it's now becoming quite clear that the distinction between abstraction and representation is a false concept. It was a critic's idea, not an artist's concept. It's all one thing.

GN: What really impresses me is your openness to all these technologies. A lot of people are really scared. They don't want to touch a computer, they don't think it can create art. And you, instead of being scared, are saying, "Get out of the way—let me at it." It's another tool, right?

DH: It's just another medium, that's all.

David Hockney, *Henry Geldzahler, #1*, September 5, 1990

Collapsing Hierarchies: Photography and Contemporary Art

By Carter Ratcliff

Two centuries ago few could afford to travel for amusement and the camera had not been invented. Yet the desire for pictures of foreign places was as strong then as it is now, and those able to take the Grand Tour could hire a draftsman to record sights seen along the way. In May 1794, the 22-year-old John B. S. Morritt arrived in Hungary with his friend and tutor, Robert Stockdale. In a letter to his mother at Rokeby, the family estate in Yorkshire, Morritt wrote, "We have been inquiring after a draughtsman, and I hope we have heard of one who will suit." They had, and on their way through Vienna, this functionary was engaged.[1]

Nowhere in Morritt's long epistolary account of his travels does the draftsman's name appear. He was more anonymous than a camera (a contemporary postcard from a faraway place might mention a Nikon or a Minolta). Nonetheless, he did the camera's job, which his employer described in familiar terms. "You have no doubt read a great deal about the situation of Constantinople," Morritt wrote to his sister Anne, "and know the raptures in which it is generally described. I employ my draughtsman all day in taking views of it, and I assure you I think it baffles almost as much his pencil as my pen." In a village of the Peloponnesus, Morritt wrote in another letter, a woman gave this tireless personage "permission to take her picture."[2]

This locution implies an exchange: the tourist gives his attention to a foreign place; in return, he takes away an image of it. We Westerners go abroad to find certain qualities of experience, and we tend to feel that we have not struck a good bargain—we have cheated ourselves—unless we come home with evidence of having found what we sought. The traveler's experience must register as a series of images, whether in pencil on paper, on film, or on the videotape of a minicam.

The camera is an affordable substitute for the traveling draftsman, and at least one of photography's inventors, William Henry Fox Talbot, was motivated by the wish to make precisely that substitution. In the preface to *The Pencil of Nature* (1844–46), Talbot describes his struggles to record his travels with a camera lucida. Judging his efforts "melancholy," he thought "how charming it would be if it were possible to cause these natural images to imprint themselves durably, and remain fixed upon the paper!"[3] In 1839 he succeeded in finding the chemical means to render a camera image permanent.

Since Talbot's time photography and other media have existed in an uneasy, and often contradictory, relationship to one another. Many artists have used photographs as functional, and sometimes formal, equivalents to drawings. Because this practice compromises photography's independence, we often ignore it. The Surrealist Max Ernst, for example, moved freely across the borders between mediums. He hoped that by juxtaposing

photography, drawing, and engraved illustrations in a single work, he would generate dissonance—an esthetic disharmony with social overtones, like a soiree with a jarring mixture of guests. At Robert Rauschenberg's party, those tensions are absent. In *Factum I* and *Factum II*, a pair of paintings made in 1957, Rauschenberg placed brushwork and mass-produced imagery side by side, as Ernst and other Surrealists had done. Yet there is a difference. In the *Factum* pictures, painting and mass-produced imagery meet on equal terms.

Here, news photos clipped from a tabloid are stronger presences than the splashes of paint afloat in the gaps between them. Two newspaper photos of then-president Eisenhower appear under a transparent scrim, as if this sort of imagery is so powerful that its impact must sometimes be blunted. Toward the

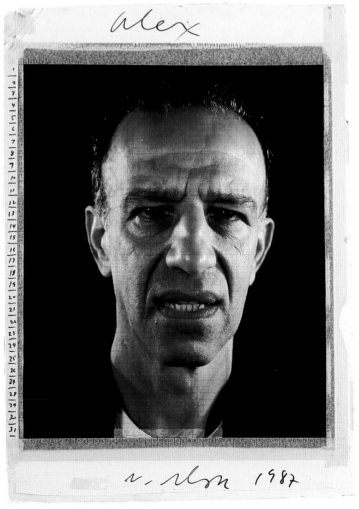

Chuck Close, *Maquette for Alex Katz*, 1987

Chuck Close, (right) *Alex*, 1991

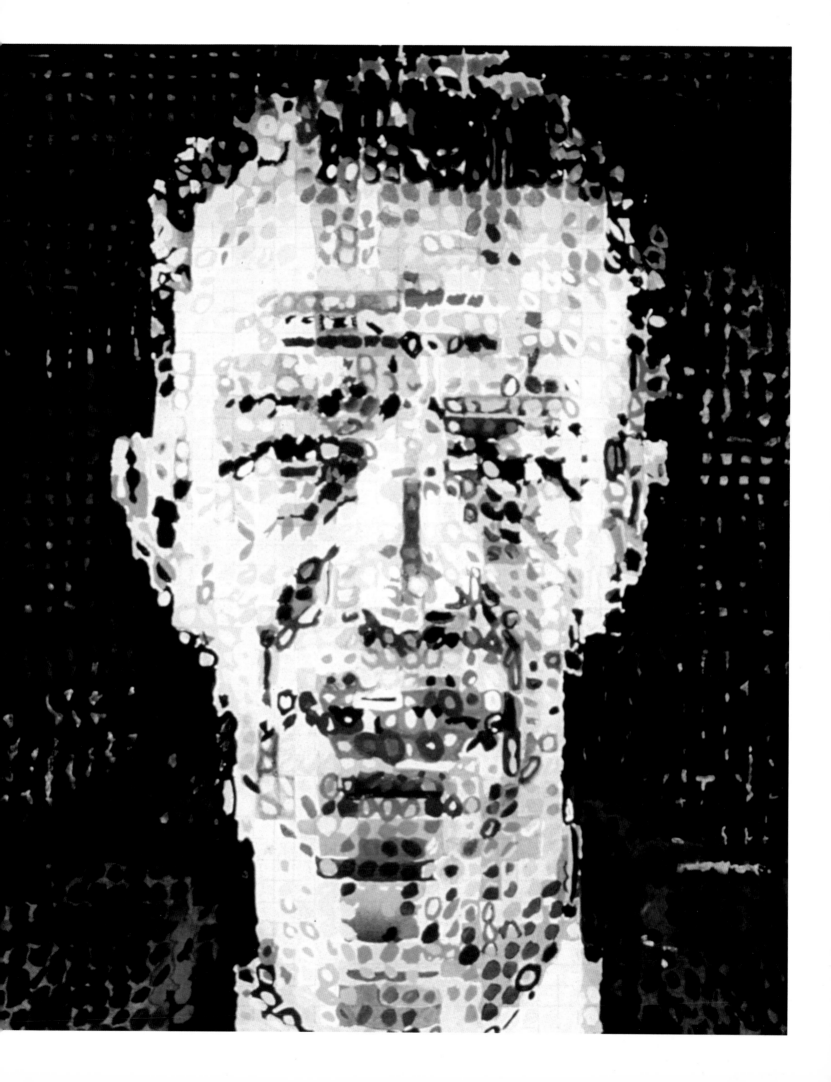

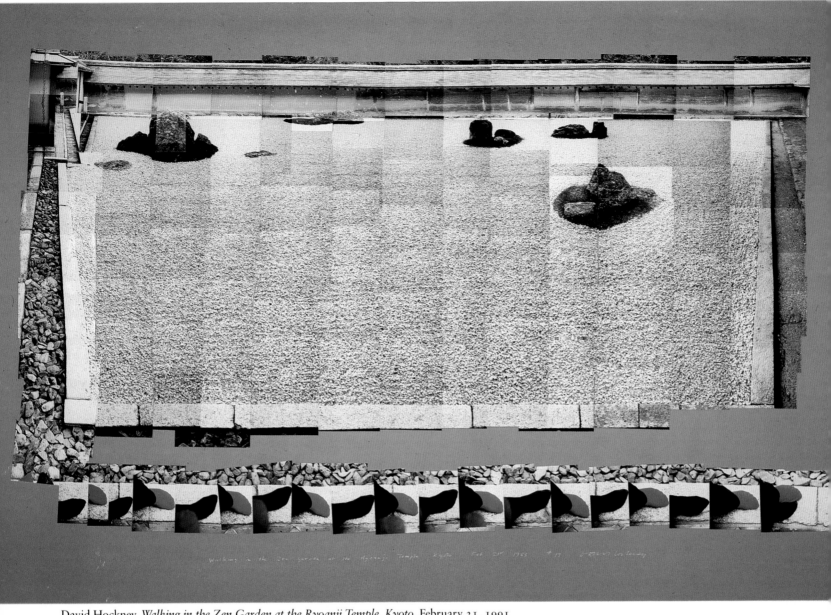

David Hockney, *Walking in the Zen Garden at the Ryoanji Temple, Kyoto*, February 21, 1991

middle of each *Factum* canvas, there is a swatch of upholstery bearing the same fragment of a trite landscape—two trees, a lake, a wooded hillside. These may be photo-silkscreen images, and may have been designed by a hand guided by a photographic source. As he establishes the equality of his mediums, Rauschenberg sometimes lets their identities blur. He makes no attempt to disguise the presence of oil painting in the two *Factum*s. Yet, in making the second of the two works, he repeated with remarkable accuracy the brushwork of the first, suggesting that marks of the painter's hands, no less than a photograph, can be replicated.

Rauschenberg displays neither respect for the high status of painting and drawing nor the disapproval of these "aristocratic" mediums that Duchamp implied with his aesthetic of the ready-made. Rauschenberg is an egalitarian without irony. By the mid 1950s, all his mediums were at play on the immense, level field of his aesthetic. Undermining the hierarchy of mediums is for

him part of a frantic but always amiable effort to deny all differences in status, including those that separate the various styles, themes, and sectors of Western culture.

Near the center of *Barge*, 1963, a painting over thirty-two feet wide, is the artist's wittiest denial of hierarchy: the juxtaposition of two photo-silkscreen images, the Rokeby Venus, by Veláz-quez, and a bird's-eye view of a particularly complex cloverleaf interchange. Each echoes the other's curves with amazing finesse. The effect is still startling, and it is sensual in ways not anticipated by familiar ideas about Venuses and automotive travel.[4] Whitmanesque in its optimism and its unbounded sprawl, Rauschenberg's art established a state of complete equality between black-and-white snapshots, photos reproduced in four color, photo-silkscreen imagery, photo-lithographs, drawings, passages of painting, sculptural devices, assemblage, and all his other mediums and methods, including dance. In his art, the collapse of hierarchy is thorough.

One can acknowledge that painting, drawing, and photography have typical characteristics, yet not feel obliged to believe that each visual medium has an inviolable essence.

Sol LeWitt, *Walls of the Lower East Side*, 1979

The roster of painters who have used photographs as drawings is crowded, yet among them Rauschenberg's name stands out, for he was the first artist to treat photography, drawing, and painting as absolute equals. Andy Warhol sensed Rauschenberg's egalitarianism, then schematized it. With their extreme tonal contrasts, Warhol's photo-images of Marilyn, Lisa, and Coke bottles have the stark look of line drawings. Warhol taught photography to be as elliptical as his own impatient hand, and from him the artists of the 1980s learned much of what they know about generating punchy, high-contrast images. Cindy Sherman, Robert Longo, Richard Prince, James Welling, David Salle—these and other artists take for granted the interchangeability of photography and drawing. Caring little about the autonomy of visual mediums, they cultivate the traits that photographs can be made to share with drawing—salient line, tonal extremes, quick clarity.

Wiry black line in high contrast to white paper gives strength to the flower drawings and occasional portraits of friends that Ellsworth Kelly has made throughout his career. Turning from these images to his shaped, monochrome canvases, one might get the impression he leads a double life: pencil in hand, he is a severe sort of realist; when he paints, he becomes an abstractionist with affinities to the geometric painters who preceded him in the 1930s, and to the Minimalists who appeared in the '60s, when Kelly was well established on the New York scene. His oeuvre is disparate, undeniably, yet it is unified by the use he makes of the photographs he has taken, sporadically, throughout his career.

The subjects of his camera are usually architectural, with unexpected formal emphases. The artist has said that overcast days bore and even depress him. He likes bright days,[5] a preference that generates photos organized by the patterns of strong shadows. From photos taken in full sunlight Kelly gets ideas about shapes and their relationships, and about the power of viewpoint to set symmetries askew. As expounded by his camera, these are subtle ideas, so the pressures they exert on the artist's luminously monochrome paintings are too delicate to be gauged with much accuracy. Kelly's drawings of flowers and faces have obvious connections to the world. Nearly unseeable yet just as firm are the links between observed appearances and his seemingly abstract paintings, links sustained by the kind of looking that, on occasion, his photographs register.

Though he often is grouped with the Minimalists, Kelly is a contemporary of Cy Twombly and Jasper Johns. Like them, he is devoted to nuance and the devices that make it elusive. The

Minimalists banished nuance and its attendant ambiguities in favor of manifest order, which they established with clear concept and impersonal fabrication. Their most dramatic demonstrations of orderliness are three-dimensional: Robert Morris's cubical boxes, Donald Judd's oblong ones, the "carpets" Carl Andre built from square metal plates.

Sol LeWitt also built rectilinear objects, boxes, and gridded lattices. In 1968 he began to make wall drawings—graphite-on-white patterns of vertical, horizontal, and diagonal lines as orderly as his sculptures or more so, for they occupy only two dimensions. Yet irregular lines soon appeared, and color not long after. LeWitt seemed to be flirting with the idea of disorder.

By 1977 the flirtation had become a tentative embrace. Shifting from drawing to photography, he composed a grid from squared-away snapshots of paneled doors, intricately glazed windows, tiling, grates, architectural facades. Nearly all the images in these *PhotoGrids* are of flat and crisscross forms. Also in 1977 he photographed the roughly rectilinear patterns of a casually finished brick wall. Shadows cast by the sunlight raking its irregular surface imply weather and time, themes LeWitt's art would not have touched in earlier seasons. By 1979 he had shown square photos of sunrise and sunset. Naturally, the images were arranged in grid patterns, as were the snapshots of his studio and bookshelves that compose *Autobiography* (1979). These works seem to present clear instances of photography taking the place of drawing. In *PhotoGrids*, *Wall of the Lower East Side* (1979), and *Autobiography*, imagery generated by the camera has a regularity roughly equivalent to the geometric order of LeWitt's severest drawings.

Minimalism's impersonal style of order seems to have alerted Chuck Close to the grid's power as a transforming agent. The process that takes his images from photo to painting begins with a Polaroid close-up of a face. Squaring off the photographic image, he lays the same grid on his canvas, at a larger scale. Then he transfers the visual data in each cell of the photo-grid to the corresponding cell of the painting. Polaroid dyes become patterns in pigment. Concentrating on the accurate transference of detail from one medium to the other, Close loses sight of his subject, almost becoming an abstract painter while a canvas is in progress. When it is done, a recognizable image appears, at least from a distance. If one examines the surface from a few inches away—the artist's working distance—the image separates into a dense texture of minute spots of color. It becomes an abstraction, and one gets a sense of the rules of equivalence Close followed as he turned a small snapshot into a monumental portrait.

In the late 1960s and early '70s, those rules mimicked the constraints imposed by the process of color printing; each detail of a face was built from roughly equal touches of primary hues. In early black-and-white works, tonal contrasts took the place of color variations. Since then, he has made a number of methodical changes in the rules of transfer, altering the size and shape of his brush stroke, and in some works building the image from the thumbprints in black ink. What is compelling about Close's method is the way it insinuates his touch into a process usually carried out by machines. With their photo-silkscreens, Rauschenberg and Warhol let strongly mechanical flavors seep into their images. Close's portraits not only are, but look, handmade. Also, they look photographic, so there is a choice: one can see him as having triumphed over photo-mechanics, as having learned to work with the camera in a spirit of complete cooperation, or as having done both.

From the history of modern images, Close learned how to make photos function as drawings. More specifically, he adapted to representational painting the literalist tendencies that led Minimalists to abstract sculpture. Innovation like this counts as avant-garde progress. David Hockney had long complained that the idea of progress in aesthetic realms is delusive, and so it is not surprising that he sometimes makes photos and drawings in an old-fashioned way. A compulsive traveler, he has long made drawings of exotic places. Without abandoning this practice, he began to take photographs while traveling—"holiday snaps," he called them, derisively, on the assumption that they weren't of much interest to anyone but him and his friends.

When Hockney did give photography his serious attention, he was prompted not by the history of the medium but by its claims to truth. Lecturing in 1983, he asked, "Why is a painting based on the camera [image] (and with one viewpoint) more interesting than a photograph taken from the same spot?" Not everyone would agree with the premise of this question: why assume that the painting will of necessity be better than the photo? Hockney would reply that it is because the camera takes an image all at

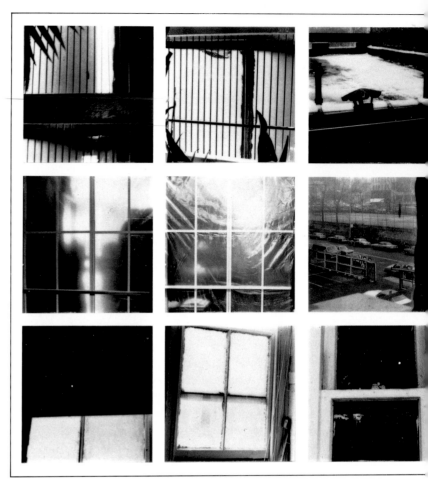

Sol LeWitt, *Autobiography*, 1979

The fact that drawing and photography can be induced to exchange roles offers a particularly important instance of give and take, for it teaches us much about the economy of the aesthetic in modern times.

once, in an instant, giving it a static quality. By contrast, he would add, the painter must render his photo-based picture by hand, over time, and this brings the image to life. He finds his chief examples of this liveliness in Venetian views by Canaletto, made not with a camera but with an eighteenth-century camera obscura. Echoing George Moore's complaint that photography is a bad influence in modern times, Hockney says that he can usually tell when contemporary artists make drawings and paintings from photos. The hand mimics the lens's instantaneous effects, and the image goes dead.[6]

Hockney's solution to this problem was to assemble a photopiece—what he calls a "joiner"—from many shots of the same subject taken over a period of time as long, in some instances, as "four or five hours." When a "joiner" is a portrait, it can show the same face from several angles, and with the various expres-

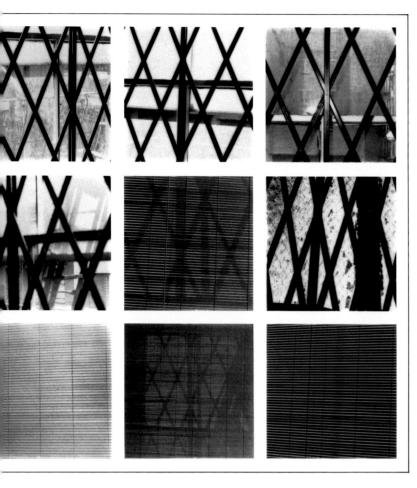

the National Gallery, in London. The appearance of photography did not inspire a new hierarchy but, instead, provided an opportunity to elaborate and to reinforce an old one: tradition was to be elevated at the expense of innovation. Photography's partisans reversed that tactic with the argument that, properly employed, it is as "aristocratic" a medium as painting or drawing.

The best modern artists are often the ones most impatient with all instances of hierarchy. So the liveliest relations between "aristocratic" drawing and "middle-class" photography have been initiated by sensibilities unburdened (or at least not inhibited) by anxieties about social class. Disinclined to retreat to a sanctuary where the practice of art enjoyed special privileges, Rauschenberg said he wanted "to act in [the] gap" between "art and life."[8] Despite his patronizing talk about proper drawing, Hockney is not a snob; in fact, his art often celebrates his working-class origins. Warhol was a snob, yet he too acknowledged—in a way, flaunted—his family's immigrant background. Willing to let the various mediums mingle as equals, these artists are especially good at revealing the patterns of exchange that art instigates. Unimpressed by the hierarchies that attempt to raise art far above the marketplace, these artists understand that the aesthetic is also economic, for it generates value from exchange. One takes, as in taking a picture; the other gives, as when the subject renders up a meaning. Aesthetic value arises from patterns of give and take, some crude (as in those between artists and collectors), others subtle to the point of evanescence.

Sometimes, players exchange roles. Think of Warhol not as an artist but as a collector of Deco furniture and Indian artifacts and much more, or think of his art as an obsessive kind of scavenging. Some collectors think of themselves as artists, not merely accumulators but impresarios who express grand sensibilities through the medium of others' works. The fact that drawing and photography can be induced to exchange roles offers a particularly important instance of give and take, for it teaches us much about the economy of the aesthetic in modern times. The first lesson is the most important: precisely because the esthetic is economic, a pattern of exchange, the meanings of artworks and even the definitions of mediums are utterly contingent. Nothing can be known in advance. One must elicit meaning from immediacies, like an artist who has taken a picture and is now waiting for the image to emerge. □

1 J. S. B. Morritt, *A Grand Tour: Letters and Journeys 1794-96* (1914; London, 1985), pp. 36, 42. 2 Ibid., pp. 68, 115-16, 202. 3 William Henry Fox Talbot, "A Brief Historical Sketch of the Invention of the Art" (1844), *Classic Essays on Photography*, ed. Alan Trachtenberg (New Haven, 1980), pp. 28-29. 4 From Rauschenberg's willingness to treat photos as the equal of drawing flowed large implications, which Brian O'Doherty illuminated with his idea of Rauschenberg's "vernacular glance." See O'Doherty, "Robert Rauschenberg: The Sixties," *American Masters* (1974; New York, 1988), p. 198. 5 Ellsworth Kelly, in conversation with the author. 6 David Hockney, "On Photography: A Lecture at the Victoria & Albert Museum" (1983), *On Photography* (New York: Andre Emmerich gallery, 1983), pp. 9-11, 21. 7 Ibid., pp. 11, 16-20, 22. 8 Robert Rauschenberg, statement (1959), *Sixteen Americans*, exhibition catalogue, ed. Dorothy C. Miller (New York: The Museum of Modern Art, 1959), p. 58.

sions it assumes over time. Taking a landscape as its subject, these multiple images can evoke the time one spends scanning the terrain to get a sense of its shape and its scale. They can give the viewer an idea of the artist as a presence in the landscape, responding to it. Naturally, these photo-pieces affected his paintings, which began to adopt shifting viewpoints and sudden jumps in scale. His sense of painting's history was also affected, as he came to understand that his experiments with the camera recapitulated much that the Cubists painters accomplished when they played with multiple points of view.[7]

Sometimes Hockney accompanies his objections to the idea of avant-garde progress with charges that today's art students are not capable of proper drawing. Polemics like these make him sound like a conservative belligerent in the defence of tradition, yet he has done much to undermine the hierarchy of mediums. In his oeuvre, photography, painting, and of course drawing affect each other deeply and on equal terms.

The notion that some arts are "fine" and others merely "applied" took shape in the Renaissance, and has been reshaped surprisingly little by the passage of centuries. We would have no difficulty in understanding the distinctions of status that, in Morritt's eyes, separated his anonymous draftsman from Velázquez, whose Venus hung at Rokeby until it was bequeathed to

The Shape of Seeing: Ellsworth Kelly's Photographs

The following are excerpts from a conversation between Ellsworth Kelly and Charles Hagen, August 1991:
I began taking photographs in 1950, in France. Earlier that year in Paris, I had started to make collages of fragments developed from shadows and architectural motifs. Of course I was also painting then. While visiting some friends in the country, I borrowed a Leica; it was the first time I used a camera to make notations of things I had seen and subjects I had been drawing.

I had the film developed, but the pictures didn't interest me because they were small and weren't printed very well. In 1970 Diane Waldman included them in a book of my drawings, the first time any of my photographs had been reproduced.

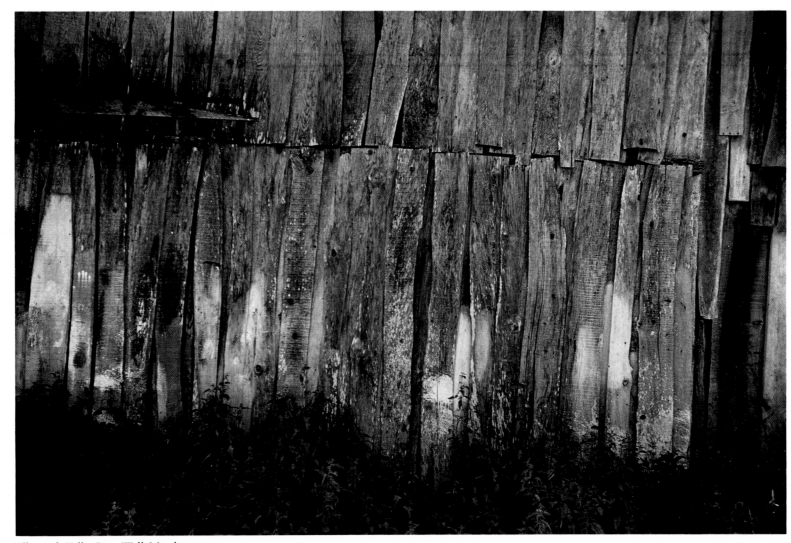

Ellsworth Kelly, *Barn Wall*, Meschers, 1950

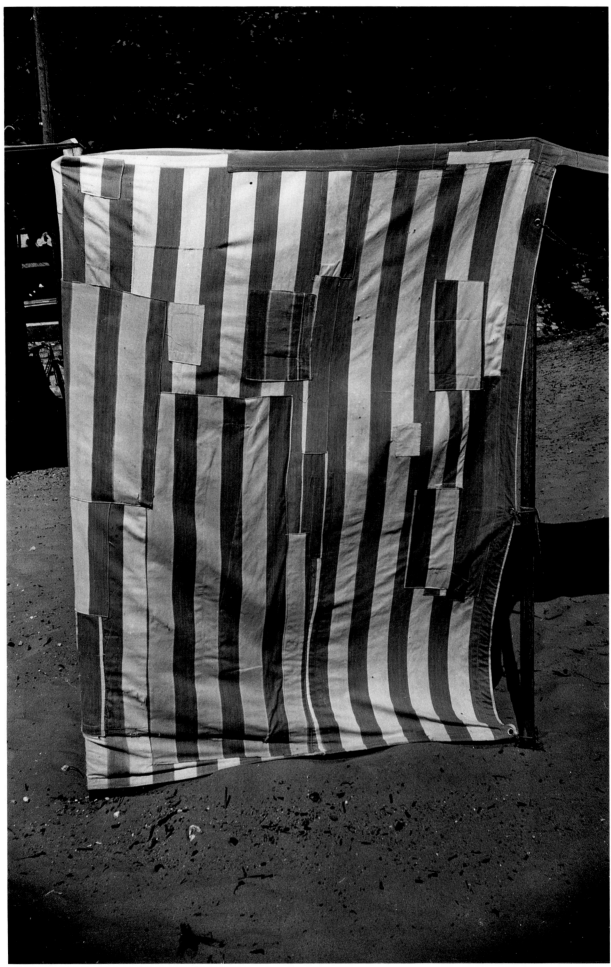

Ellsworth Kelly, *Beach Cabana*, Meschers, 1950

Ellsworth Kelly, *Roof*, Ghent, 1972

I start with a shape, and if I need
something more I add to it.
When you look at the world,
everything is separate—each thing
is its own, in its own space,
has its own uniqueness.
When I take photographs
I want somehow to capture that.

I'm not sure when I finally bought a camera—maybe it was in the late '60s. When I went back to Paris in 1967, I photographed old walls and subjects I had made paintings of, just to record them. These and the earlier photographs will be shown in 1992 at the Jeu de Paume, in Paris, with paintings and reliefs from 1948 to 1954. There will also be a room of photographs with related drawings. My earlier photos had been like sketches or drawings, but I also photographed things I wouldn't ordinarily make drawings of—brick walls, leaves, trees—that were in some way related to work I was doing.

In Bridgehampton on Long Island, in 1968–69, I did a series of photographs of barns. I thought the barns related to my paintings in their form, as an architectural statement, the way

they divided up space geometrically. I've never thought of my painting as architectural, but a lot of the work springs from architectural motifs.

Photography is for me a way of seeing things from another angle. I like the idea of the interplay of two and three dimensions. My photographs are simply records of my vision, how I see things. My ideas develop from seeing, not from the photographs.

My paintings never develop from photographs directly. When I tried once, the form that I had been interested in didn't exist outside of the photograph. The magic was in the photograph and it stayed there.

Things that interest me visually are things that anyone could

have seen, from the beginning of time. Early man could have seen the shadows, outlines of forms, and dimensional space, but they were of no use to him. Two things interest me in particular; one is the way a frame—a window, an aperture—changes what you see. You can focus on things differently and frame them differently; your vision becomes fragmented. The other aspect is stereoptics—the fact that we have two eyes, and that we see things differently out of each. It's very mysterious, but we tend to take that aspect of vision for granted.

Photographs lack the power that our two eyes give us, the ability to upset our certainty about what's out there. I remember once in Paris I was lying under a tree, looking up through the leaves. I closed one eye, and it looked like a tapestry, flat, with a thousand different overlaps. Then I opened both eyes, and it was amazing, like a canyon, with great depth. Often when I draw I close one eye, to test the overlaps. In my flower drawings, I'm not interested in making things look round, only in how forms overlap, and in exaggerating the difference between what's near to you and what's farther away. Matisse and Picasso were interested in that aspect of line drawing. Picasso is very precise in the overlaps of his drawings, very clear about the space. Matisse can make one side of a line white and the other gray, just by how he curves the line.

Photography is about seeing in three dimensions and trying to bring it into two dimensions in a way that recalls the third. The process takes place in the mind. As we move, looking at hundreds of different things, we see many different kinds of shapes. Roofs, walls, ceilings are all rectangles, but we don't see them that way. In reality they're very elusive forms. The way the view through the rungs of a chair changes when you move even the slightest bit—I want to capture some of that mystery in my work. In my paintings I'm not inventing; my ideas come from constantly investigating how things look.

My paintings are an open situation. I want to make a shape that somehow or other is in my mind, or that recalls something once seen. I work with simple shapes, but I don't eliminate elements to get to them. I start with a shape, and if I need something more I add to it. When you look at the world, everything is separate—each thing is in its own space, has its own uniqueness. When I take photographs I want somehow to capture that.

I became interested in nineteenth-century photographers like Timothy O'Sullivan, William Bell, and Carleton Watkins when I saw an exhibition at the Metropolitan Museum of Art entitled "Era of Exploration." At the time they were working, those photographers were doing things with form that no one was doing in painting. I've always thought their work was about vision. I'm also fascinated by the work of Eugène Atget. Paris became his excuse to make photographs that were unique and highly personal expressions of his vision.

Photographs provide a kind of validity—a "significance of facts." But is everything visible? As we look out into the world, everything seems to move constantly in a kind of visual chaos. Art is about trying to get to the truth, however intuitive. In 1932, Edward Weston wrote:

> *Fortunately*, it is difficult to see too personally with the very impersonal lens-eye; through it one is prone to approach nature with desire to learn from rather than impose upon, so that a photograph, done in this spirit, is not an interpretation, a biased opinion of what nature *should be*, but a *revelation*—an absolute, impersonal recognition of the *significance of facts*.

Jack Shear, *Ellsworth Kelly*

45

Ellsworth Kelly, *Sidewalk*, Los Angeles, 1978

*My paintings never develop from photographs directly. When I tried once,
the form that I had been interested in didn't exist outside of the photograph.
The magic was in the photograph and it stayed there.*

Ellsworth Kelly, *Porch Shadow*, Spencertown, 1977

Ellsworth Kelly, *Doorway*, St. Barthelémy, 1977

Landscapes of Form

By Toshio Shibata

At the age of sixteen I began studying to be a painter. In the 1970s I experimented with a variety of media, including prints and photography, but since around 1980 I have concentrated mainly on photography. In it I found a direct power of expression that compelled me to discard all of the other techniques I had learned. For me, the camera is the device best suited to capturing that initial desire that turns the artist toward the blank page when starting a drawing, for example.

Toshio Shibata, *Saito City, Miyazaki Prefecture*, 1990

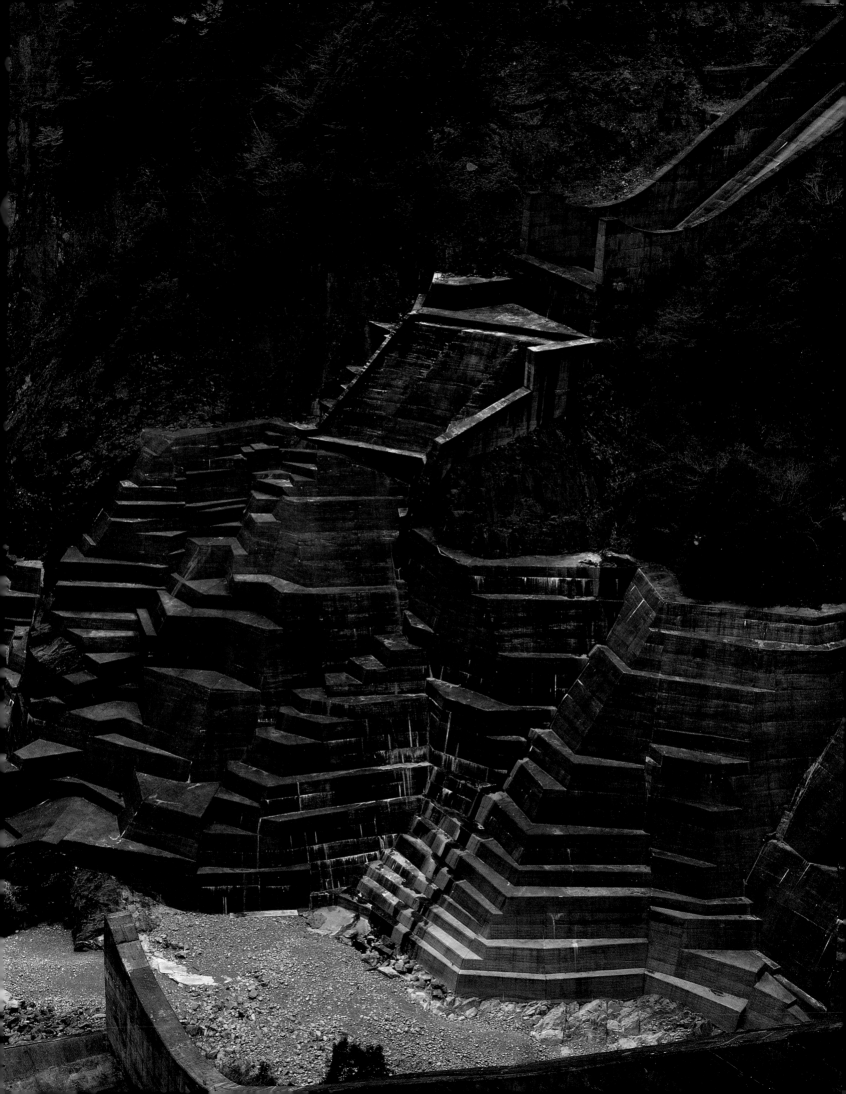

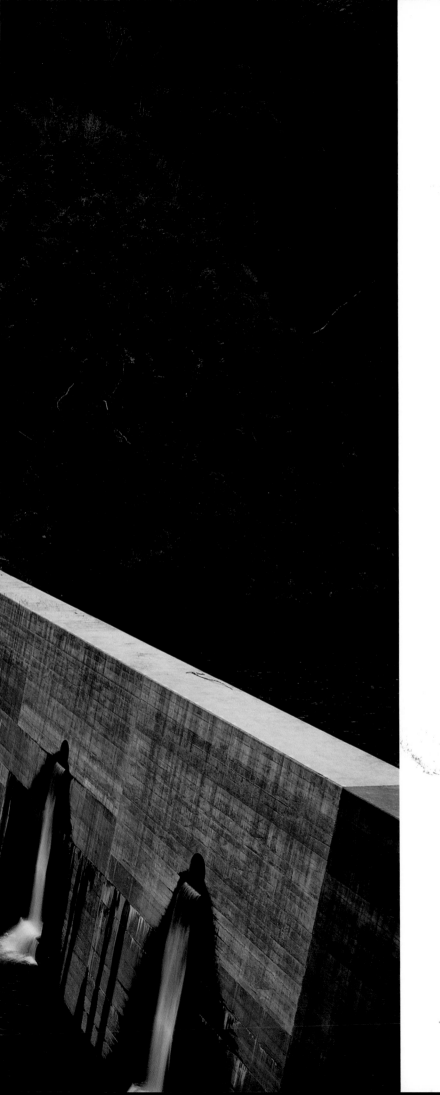

Yet when one views a photograph, the gaze is not led directly in to the artist's mind; it tends to be attracted first to the subject of the photograph. The photographer must draw that straying gaze back inward, which can be especially challenging in the case of a photograph whose subject is based in reality. The only thing that makes this possible is the presence of the artist's pure desire to give expression to something, revealed on the surface of the print.

Toshio Shibata, *Shimogo Town, Fukushima Prefecture*, 1990

51

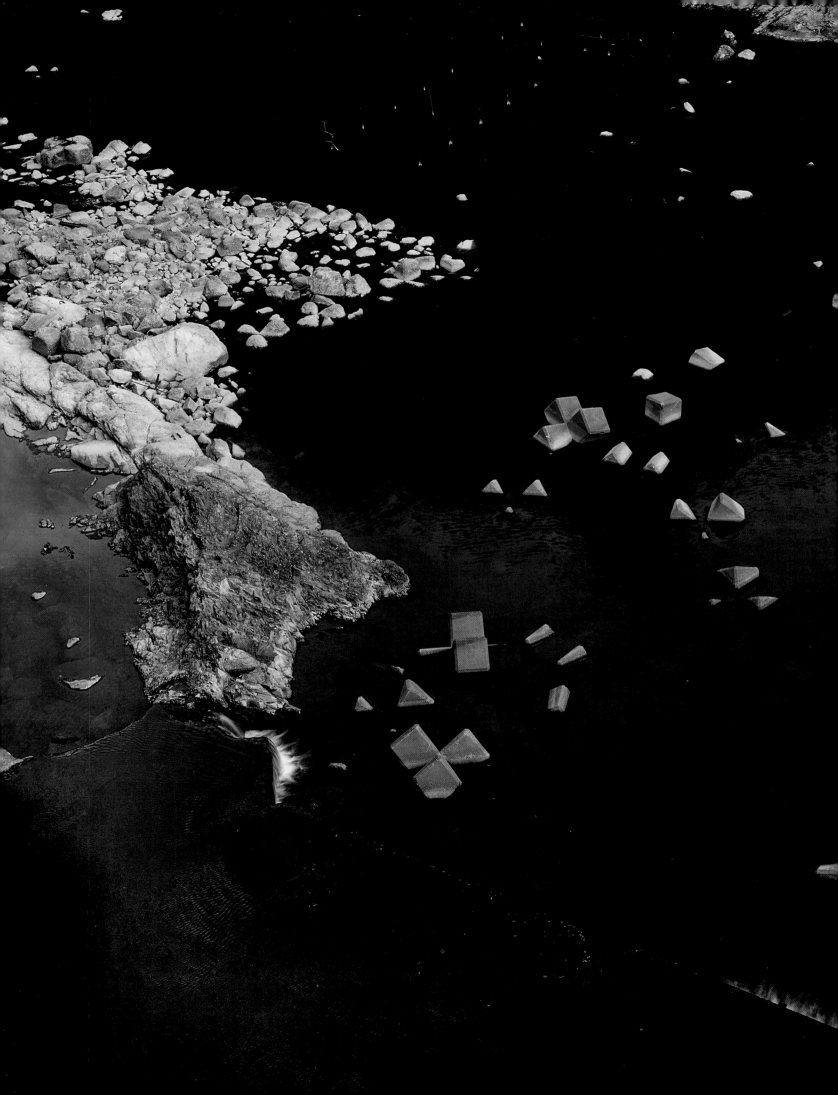

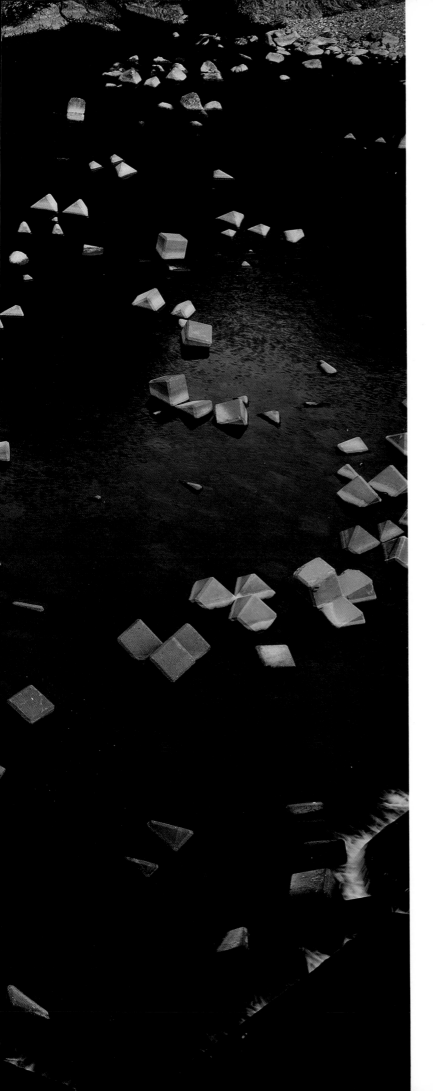

What a single photograph is ultimately capable of presenting is the stance and reaction of the photographer confronted with his subject—an emotion, an intention, a judgment.

Toshio Shibata, *Tajima Town, Fukushima Prefecture*, 1989

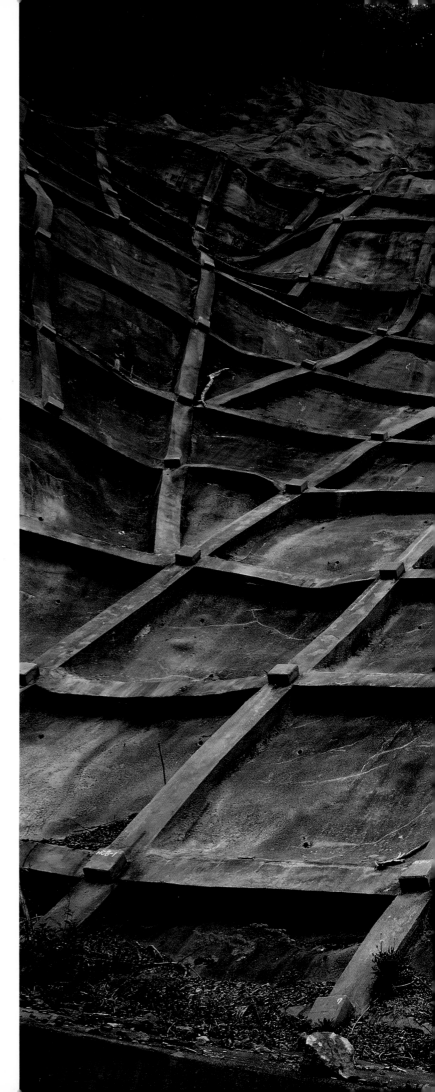

The distinction between drawing and photography is merely a technical one, in which I have little interest. The important issue is whether or not one's desire is channeled purely into expression. But, of course, what makes photography appealing is its directness and its feeling of exploration—what you might call an openness to the outside world and a sense of the mystery of discovery.

Toshio Shibata, *Shiiba Village, Miyazaki Prefecture,* 1990

The Encompassing Eye: Photography as Drawing

By Charles Hagen

"The Encompassing Eye: Photography as Drawing" begins from a historical fact: that photography at its inception was seen by many observers as a particular, almost magical kind of drawing.[1]

This is expressed most famously in William Henry Fox Talbot's description of the events that led him to discover his photographic process, when he grew dissatisfied with his inept attempts to draw scenes around Lake Como, during a visit there in 1833. As a result, he writes, he returned home to England resolved to perfect a means of recording the "fairy images" of the camera obscura in a permanent way.

As Weston Naef writes in his essay "Daguerre, Talbot, and the Crucible of Drawing" (page 10), early commentators, with no exact models to compare the new medium to, returned consistently to the closest parallel to it they could think of—drawing. Again, Talbot himself provides the best evidence of this, referring to the first results of his process as "photogenic drawings" and giving his pioneering exploration of the characteristics of the new medium the title *The Pencil of Nature*.

That terms from drawing should be used to describe photography in this way is not surprising. As Naef further points out, drawing occupied an important place in the training and practice of artists in the early nineteenth century. Moreover, the ability to draw was seen as an essential skill for cultured people of the time—which no doubt added to Fox Talbot's frustration at his own lack of abilities in this direction. But in a larger sense, this early confusion over how to describe photographs prefigured a more essential debate that continues today, over just what photography is—or, as the debate is more often presented, what it *should* be. The definition of photography has always been a matter of critical argument and struggle, reflecting continuing uncertainty about the nature and most appropriate use of the medium.

One side of this debate over the capabilities and proper use of the medium was exemplified by the painter Sir William Newton, who argued in 1853 that "the general tone of nature has yet to be accomplished by means of Photography." "I do not conceive it to be necessary or *desirable*," Newton continued, "for an *artist* to represent or aim at the attainment of every minute detail, but to endeavour at producing a broad and general effect. . . ." To achieve this end, Newton proposed a controversial step: "I have found in many instances that the object is better obtained by the whole subject being a little *out of focus*, thereby giving a greater breadth of effect, and consequently more suggestive of the true character of nature."[2]

The other side of the debate over the nature of the medium was articulated in 1857 by Lady Elizabeth Eastlake, in a famous essay in the *Quarterly Review*. Describing Nicéphore Niépce's discovery of the process of developing a latent image, Eastlake

The definition of photography has always been a matter of critical argument and struggle, reflecting continuing uncertainty about the nature and most appropriate use of the medium.

wrote of ". . . the high philosophic principle, since then universally adopted in photographic practice, which put faith before sight—the conviction of what must be before the appearance of what is."[3] The trust in the machine that this phrase implies—in the images provided by the apparatus over one's own vision—is another way of expressing one side in the long-standing opposition between science and art, fact and expression. In arguing for reliance on the images provided by science and technology Eastlake reflected the self-doubt of modern industrial culture, and its continuing attempts to locate a standard of certainty outside itself.

Photography, Eastlake declared further, "is made for the present age, in which the desire for art resides in a small minority, but the craving, or rather the necessity for cheap, prompt, and correct facts in the public at large." Photography's business, she continued, "is to give evidence of facts, as minutely and as impartially as, to our shame, only an unreasoning machine can give."

Eastlake described the essential character of art in very different terms, linking it to the will of the artist rather than the apparent certainties of the machine. "Whatever appertains to the free-will of the intelligent being," she declared, "as opposed to the obedience of the machine,—this, and much more than this, constitutes that mystery called Art. . . ."

While this debate continued in photographic circles, photography quickly became established in the popular mind as a medium with a special link to reality. Its capabilities as a

Michael Spano, *Construction #41*, 1990

Jan Groover, *Untitled*, 1985

These photographs originated from my desire to document condolence notes our family received when my father died. The handwriting itself became more poignant and evocative for me than the messages conveyed. Handwriting then took on new interest when greatly enlarged. Paradoxically it became more intimate as it got larger. It reminded me of my genitalia pictures, or possibly my pictures of faces, where I had tried to express that moment of consciousness on the body. I believed that the mystery of consciousness was made more explicit and graphic by magnification. It's like trying to look closer so that consciousness could even become visible in a photograph. NANCY HELLEBRAND

systematic, mathematically regular pictorial medium, in which optics and the mysterious workings of chemistry were combined in a process that could be made accessible to virtually anyone, gave it an authority in the public mind that seemed to separate it from drawing and the other arts of the hand. In place of human will, photography substituted the implacable and insistent certainties of the camera—in Lady Eastlake's approving terms, "the accuracy and insensibility of a machine." Of course, many people took great delight in making the medium contradict itself, in subverting its claims to capture and represent reality— for example, in the popular trick photographs in which, through a system of mirrors or double exposures, a person could be made to seem to talk with himself. Such humorous images undoubtedly reflected a primal, anarchic desire to keep the world free from the control of the picture—to keep Narcissus from falling through the mirror of the pond, and being swallowed up in his own reflection.

At the same time successive attempts were made to blend the authority and democratic accessibility of photography with the expression of the individual photographer's sensibility, which was regarded as the hallmark of art. The pictorialist movement of the turn of the century represented one extreme in these attempts, as photographers tried to manipulate their photographic images in astonishingly diverse ways. In 1904, though, the critic Sadakichi Hartmann sounded the Modernist call for a return to what he perceived as the essential nature of photography. "[T]he striving after picturelike qualities and effects is the

Nancy Hellebrand, (each) *Untitled*, 1990

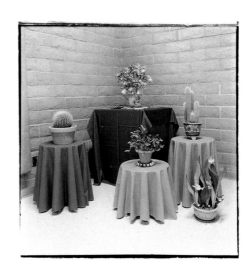

In the objects I photograph everything is transformed: furniture is sculpture, apartment façades are paintings, flower arrangements are folk art. So, too, the photographs themselves could be mistaken for drawings. Recording the aesthetic choices of others while making my own—on the surface of one photograph, my marks and theirs. JUDY FISKIN

Judy Fiskin, from the series "Some Esthetic Decisions," 1984

order of the day," he noted.[4] Foreshadowing what would become a central premise of Modernist criticism, Hartmann argued that "Surely every medium of artistic expression has its limitations. . . . The whole pictorial effect of a photographic print should be gained by photographic technique, pure and simple."

A decade later Paul Strand furthered this implicit call for trusting the machine and camera vision. In a famous Modernist credo Strand wrote that "Photography . . . finds its *raison*

To consider photography as a form of drawing is to recognize it as a picture-making medium much like any other. This involves a profound shift in the expectations one usually brings to photography.

d'être, like all media, in a complete uniqueness of means. This is an absolute unqualified objectivity. . . . The full potential power of every medium is dependent upon the purity of its use."[5]

In Europe, though, Modernism took different forms. In the 1920s a host of artists turned to photography, finding in it a means not simply of recording and reinscribing reality, but of transforming it. For these artists photography was simply another picture-making medium, although one with a special status in society. Taken in these terms, photography could be used not simply to represent reality, but to suggest new realities.

Through solarized images and photograms, Man Ray and other Surrealists could suggest dream states that transcended the physical limitations of the world. To this end Man Ray did not share Strand's concern with respecting the specific characteristics of photography. In fact, he declared in 1934 that "a certain amount of contempt for the material employed to express an idea is indispensable to the purest realization of that idea."[6]

For the Constructivists, too, the opportunities photography offered of depicting the world in a new way were more important than a programmatic adherence to a given definition of the medium. For László Moholy-Nagy, who extended the ideas of constructivism in his teaching at the Bauhaus (and later at Chicago's Institute of Design), photography could be a means of changing reality by seeing it in a new way. The photograph became the first step in a process of transformation that would end with the transformation of human consciousness. "Thanks to the photographer," Moholy wrote, "humanity has acquired the power of perceiving its surroundings, and its very existence, with new eyes."[7]

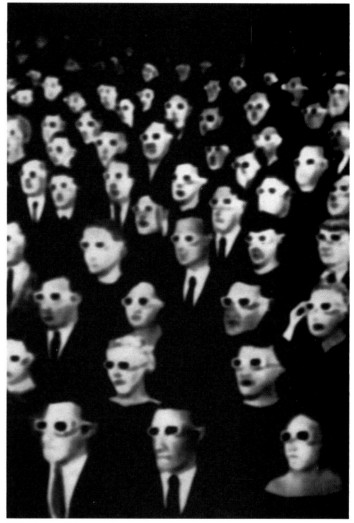

Vik Muniz, *Memory Rendering of 3-D Screening*, 1990

The radical transformation of photography these and other photographers of the time undertook paralleled a broader development within Modernism by which the expressive possibilities of abstraction were recognized. Photographers, like painters and sculptors, came to accept that even if their pictures were purged of referential meaning, the qualities of line, shape, tone, and space could themselves carry meaning. In the popular consciousness photography and drawing—the one an art of the machine, the other an art of the hand—remain radically different. But the Modernists, in recognizing the inherent meaning of photography's formal qualities, in a sense acknowledged its familial connection to the rest of art. In the process, the deep links between photography and drawing—formal, functional, and conceptual—could once again be recognized.

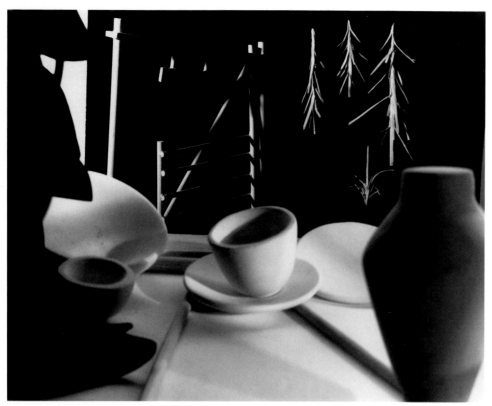

James Casebere, *Cup, Pine Trees, Gate,* 1989

Traditionally drawing has been called upon to serve a wide range of functions. Some kinds of drawing, for example—architectural drawings, carpenter's sketches, engineering blueprints, maps—are intended to be purely functional. Artists, too, have used drawings for many purposes. As sketches, drawings provide on-the-spot records which can be expanded upon and revised later, in the studio. Because of their provisional nature, drawings can also be used to make multiple views of a scene, to work toward an understanding of it in a directly visual manner. Finally, artists may make drawings purely for the distinctive formal characteristics of line and chiaroscuro that the medium allows.

For many of these purposes photographs have come to supplement or even supplant drawing. Like drawings, photographs are relatively inexpensive and technically simple to produce. Photographs also provide a wealth of detail about their subjects—sometimes, in fact, too much detail; as William M. Ivins, Jr., has pointed out, drawings are often preferred as medical or forensic illustrations, for their ability to highlight particular aspects of the subject.

Both drawing and photography are intimate media; their familiar, relaxed, amateur nature, their seemingly provisional quality, allow for the expression of personal truths. Photography, though, has an official aspect as well: it brings with it the weight of societally defined realism. In contrast, drawing is like a kind of handwriting, and can be seen as standing in the same relation to photography as script does to type, with the former handmade and the latter mechanical. Nevertheless, both photography and drawing can serve as means of depiction and discovery, and a number of contemporary photographers incorporate qualities in their work that parallel those of drawing.

By isolating objects and fragments of scenes in the photographic frame, Aaron Siskind found that he could strip them of familiar meanings. From his early photograph of a glove on a dock to photographs of patches of tar on roadways, Siskind pursued the expressive possibilities opened up by the abstract forms embodied in objects. In a series of photographs based on close-ups of quickly scribbled jottings—grocery lists, telephone notes, and so on—Nancy Hellebrand links Siskind's investigations of line to mundane scraps of writing, in pictures that are directly calligraphic. The resulting work recalls the allusive and complex paintings of Cy Twombly, which teeter on a similar edge between writing and drawing. In a recent series, Michael Spano has produced photograms that echo the formal play and exploration of Man Ray. Moreover, his reinvestigations of abstract form are marked by a strong awareness of qualities of line and tone.

Traditionally, landscapes have provided artists with a convenient jumping-off point for formal exploration. Some of Harry Callahan's earliest photographs, made in 1943, were of patterns

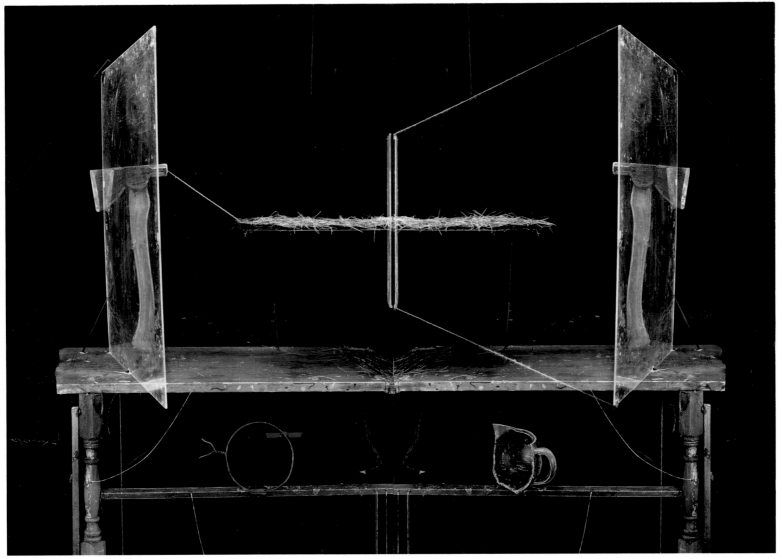

Zeke Berman, *Untitled*, 1988

The role that drawing plays in my photography has changed from a means—preliminary sketching in order to think through structure—to something closer to an end. I intend for my recent pictures to resemble photographs and drawings simultaneously.
The materials that I photograph—wire, yarn and thread—give my images a linear quality. The results are effective but point out to me a limit of the medium. No matter what I rig in front of the camera I can never reach through the lens and render within the print.
The distance is too great, but it is that distance that interests me. ZEKE BERMAN

formed by weeds and bushes, photographed and printed in high contrast. Callahan has pursued this theme throughout his career, and in his most recent pictures returns to it in close-ups of grasses and tree branches in the country outside Atlanta, where he now lives. Ray K. Metzker studied at Chicago's Institute of Design with Callahan and Siskind, and his work has long reflected the Bauhaus heritage of that program. In "Feste di Foglie" and other series, Metzker photographs landscapes emphasizing light and dark, line and tone, breaking up the images into rich formal textures. In a similar way, Lee Friedlander photographs treescapes and flowers with his customary acceptance of the allover image of the frame. The objects in each picture are presented in intricate spatial arrangements, while the compositions have the fluid, centerless quality familiar from Friedlander's other work.

Other photographers have begun to investigate familiar genres of drawing in their work. Using his own body as his prime subject, John Coplans resuscitates figure studies, that classic

John Coplans, *Self-Portrait (Standing Hand)*, 1987

A photograph is usually thought of as being made in an instant, with the image embedded in the negative, whereas a painting is arrived at by stages, drawing being the first. The apparent seamlessness of a photograph masks both the conceptual and technical stages of the making of a picture (as against the recording of an image).

The mutability of the camera and enlarger has enabled the photographer to make a wide variety of decisions and changes during the working process of making a picture. Such activity can be conceived of as "drawing" even though the surface record of this activity is not necessarily apparent to the viewer.

JOHN COPLANS

Harry Callahan, *Georgia Mountains*, 1987–90

Lee Friedlander, *Washington, D.C.*, 1976

Ray K. Metzker, *Feste di Foglie*, 1985

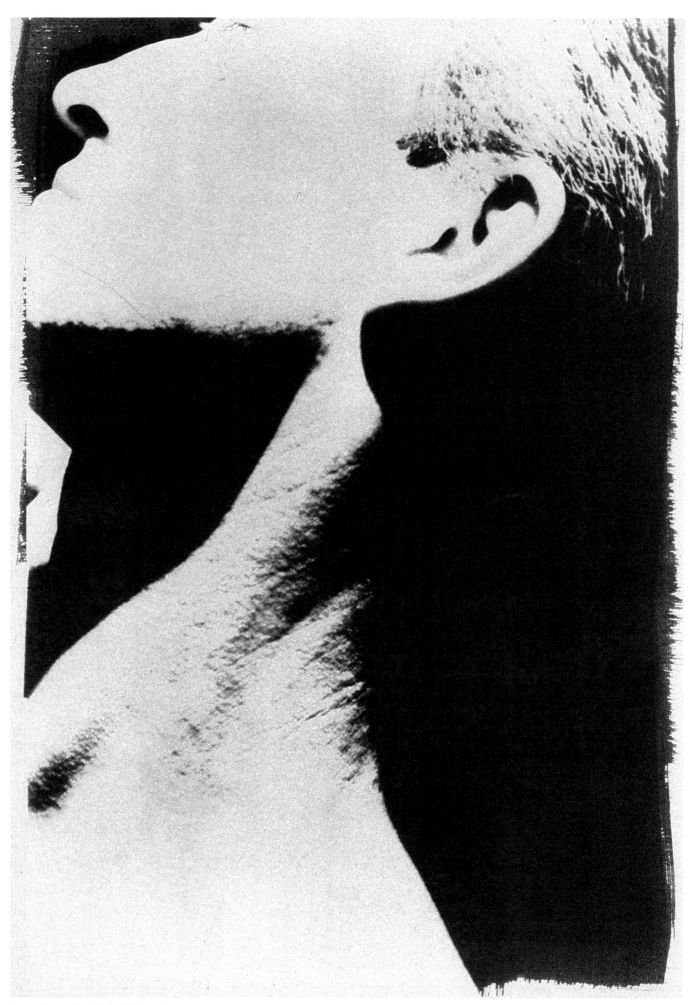

Susan Shaw, *Untitled CVX*, 1987

Aaron Siskind, *Rome: Arch of Constantine 10*, 1963

genre of drawing in which an artist records the human body while exploring formal properties. Photographing himself in strange poses and at odd angles, Coplans abstracts the familiar shapes of the body to suggest unknown creatures of the mind, or to play off the forms of classical art. Jan Groover works with the genre of still life, arranging various small items—a statue of a baseball player, a hammer, a squash—into catalogues that recall the startling conjunctions of Surrealism. By photographing these tableaus using selective focus, playing off areas of sharp detail and vague shape, Groover explores the nature of photographic attention. Los Angeles artist Judy Fiskin uses photographs to record various objects—pieces of furniture, or tract houses—in order to recognize the unity of form within these groups. Pursuing this task of cataloguing in a much less systematic way than Bernd and Hilla Becher, and with less distancing irony than Ed Ruscha, Fiskin presents her images as small prints, like pages from an intimate sketchbook.

A number of contemporary artists deliberately explore the confusions between drawing and photography, in work that has a strong epistemological dimension. As Rosalind Krauss has pointed out,[8] the question "What is it?" is central to many people's understanding of photographs. Beyond simply identifying the objects depicted in a photograph, though, we need to ask the additional question, "How is it made?" In this regard the technical information often supplied in camera magazines serves as a kind of second caption, anchoring the method of representation used in making the picture in much the same way that a descriptive caption anchors the events depicted.

In Zeke Berman's often puzzling photographs, line and shape are embedded in a representational fabric, fleshed out with detail. Berman confounds drawing and photography, setting up visual conundrums in which the familiar laws of the physical world are contradicted within the imaginary space of the photograph. James Casebere, on the other hand, uses the rich chiaroscuro tones of photography in his images of featureless white models of generic scenes—a "Mexican" village, a kitchen counter in a suburban home. Dramatically lit and photographed, then presented as prints or as large light boxes, these scenes take on an unreal air, an effect that depends in part on Casebere's rejection of photographic detail and the unnaturally smooth gradations of tone that result.

Finally, the Brazilian-born artist Vik Muniz draws what he calls "iconic images" from news photography, working not directly from the photograph but from his memory of the image. In doing so he addresses the pervasive nature of mass media imagery, in which the authority of the photograph is given even greater power by virtue of its having been so widely distributed.

It thus becomes not only a record of an event, but the event itself—the signifier separated from the signified, free-floating, archetypal.

To consider photography as a form of drawing is essentially to recognize it as a picture-making medium much like any other. This involves a profound shift in the expectations one usually brings to photography. The images it produces can no longer be seen as somehow privileged in their relationship to reality; instead they must be recognized as pictures, though of a certain historically and culturally defined sort. (By the same token, one could consider drawing as a form of photography. This would reverse the historical sequence of the two media, but acknowledge that they both reflect basic human instincts to depict and record—and imaginatively to transform—the world.)

The ongoing debate over the nature of photography—over the degree to which a photograph reflects the will of its maker, and how much credence to grant the information it provides—will only intensify as developing technology transforms its familiar modes. The evidentiary quality of the medium, which has relied on the mysteries of chemistry and optics, is being undercut by the growing tendency toward computerization of photography, allowing manipulation of the image to a greater degree than ever before. This process throws into relief the problematic and elusive nature of the medium. It also emphasizes the role of human intention as the ultimate yardstick of meaning and purpose, not only in photography but in any human activity. □

An earlier version of this article was presented at the symposium "Photography: Image/Idea/Theory," held at the J. Paul Getty Museum, Malibu, California, April 22-23, 1991. 1 Terms from drawing have continued to be used to describe photography since the earliest days of the medium. Two well-known examples can be cited immediately: Alexander Gardner called his compendium of images the *Photographic Sketchbook of the Civil War*, while the subtitle of Jacob Riis's pioneering reformist documentary, *How the Other Half Lives*, was "Sketches from the Tenements." In many cases, though, these uses of terms relating to drawing are not arguments about the nature of photography, but an attempt to convey both the impressionistic nature of the descriptions and accounts conveyed, and perhaps also to acknowledge their provisionary and partial nature. The terms thus are used metaphorically, not literally. 2 Sir William J. Newton, "Upon Photography in an Artistic View, and its Relation to the Arts," *Journal of the Photographic Society* 1 (1853), pp. 6-7; reprinted in Beaumont Newhall, ed., *Photography: Essays and Images* (New York: The Museum of Modern Art, 1980), p. 79. 3 Lady Elizabeth Eastlake, "Photography," *Quarterly Review* (London) 101 (April 1857), pp. 442-68; reprinted in Newhall, *Photography: Essays and Images*, pp. 81-95. 4 Sadakichi Hartmann, "A Plea for Straight Photography," *American Amateur Photographer* 16, (March 1904), pp. 101-109; reprinted in Newhall, *Photography: Essays and Images*, pp. 185-188. 5 Paul Strand, "Photography," *Seven Arts*, August 1917, pp. 524-526. 6 Man Ray, "The Age of Light," preface to *Man Ray Photographs 1920-1934* (Paris, Hartford: James T. Soby, 1934). 7 László Moholy-Nagy, "From Pigment to Light," *Telehor*, vol. 1 no. 2 (1936), pp. 32-36. 8 Rosalind Krauss, "A Note on Photography and the Simulacral," *October* 31 (Winter 1981).

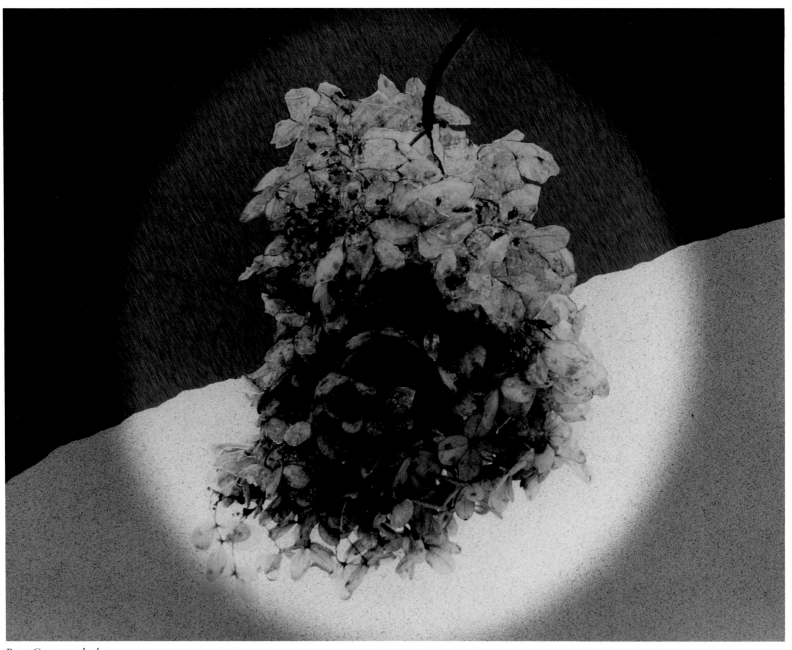

Peter Campus, *dusk*, 1991

I found this blossom outside my house. It represented something ending; perhaps its whiteness made me think of winter. The computer reduces the photo negative the way the brain simplifies what the eye sees. I can bring out the deeper meanings of my pictures, enhance them with my intentions, distort them with my fears. PETER CAMPUS

People and Ideas

LEE FRIEDLANDER,
DISPASSIONATE VOYEUR
By Vicki Goldberg

Lee Friedlander: Nudes, *photographs by Lee Friedlander with afterword by Ingrid Sischy. Published by Pantheon Books, New York, 1991 ($50.00).*

Lee Friedlander's career, like most photographers', has evolved more by changes in subject than shifts in style. His vision was established early; he has merely elucidated it and elaborated on it over time. It is a vision that has absorbed the lessons of Cubism, with its overlaps, transparencies, and fragmentations, its simultaneous views of what is in front and what is behind, its use of letters and patterns to insist on the two-dimensional surface. Yet Friedlander's work is pointedly, resolutely photographic. It is not so much about what the eye sees as about what a hand-held camera with a fast shutter speed sees—transitional movements, momentary reflections, odd bits of cityscape viewed from angles seldom lingered over, and the ironies of chance juxtapositions.

Friedlander carried this style with him when he went to look at American monuments and factory workers and to an extent when he stared at landscape, as well. The style lends itself more readily to some subjects than others and can too readily grow diffuse, but it flourishes in a show called "Lee Friedlander: Nudes" at the Museum of Modern Art this summer (not yet up at the time of this writing) and in a book, *Nudes*. This last show under John Szarkowski's aegis celebrates an aesthetic so identified with his directorship, from the 1967 "New Documents" show on, that the choice seems foreordained,

and it is fitting that Szarkowski should bow out with this surprising variation on a style that has become a near-classic with his support.

A classic in the sense of providing a touchstone, a source, and a standard, the Friedlander style is anything but classical. Many of the nude images are rather stridently anticlassical, replacing whole-

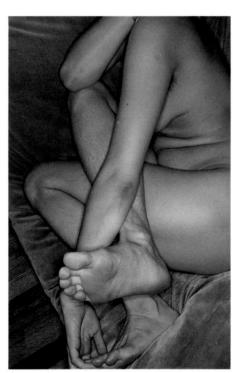

Lee Friedlander, *Untitled*

ness, grace, and accepted ideals of bodily perfection and beauty with ungainliness and rude detail. Often they refuse to offer even the classical excuse for looking at naked women: erotic enticement. Neither sex nor sensuousness has figured prominently in Friedlander's work, which is more at home in the realms of intellect

and wit than in the territories of passion. He is a cool, detached, infernally clever observer. His eye and mind light up when the right elements converge, but he does not visibly lust for the life around him—not for women on the street (as Garry Winogrand did), nor for a man's scowl or a child's smile (as Henri Cartier-Bresson did). *Like a One-Eyed Cat*, the book that accompanied Friedlander's recent retrospective, began with sleeping musicians and ended with a nude with her back turned. *Nudes* begins with a nude from the back and ends with one sleeping. Friedlander is ever the unobserved observer whose subjects slumber while he re-envisions them.

The nudes manifest all his stylistic traits, including his dispassion. There are plenty of modernist lessons here, including some post-Cubist distortions, several poses that come about as close as human beings can to exhibiting the front side and back at once (so much simpler for Picasso), even a couple of instances where light and shade break up the body into fragments and planes. Several pictures put an object—in this case a body, or a body part—on the foreground plane where it divides and blocks the view of the room much as poles and street lights sectioned off Friedlander's city streets. The puzzling and eloquent fragment at the edge of many earlier photographs is now most likely a foot or a breast that has strayed into the frame.

In the street work, the monuments, and the factory pictures, the human form was merely part of a pattern, perhaps the most prominent part because of our identification with and attachment to bodies, but with no more *meaning* and little more importance than the signs and ma-

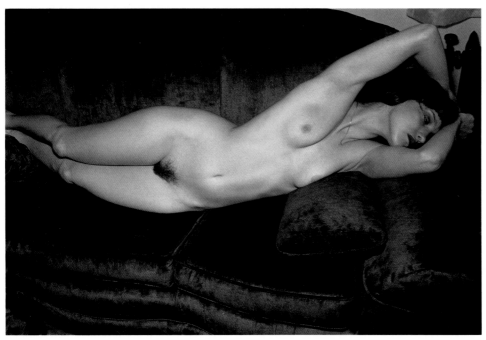

Lee Friedlander, *Untitled*

chines that had an equal claim on the photographer's attention. The nudes generally follow this prescription. Friedlander's all-devouring eye and his delight in the peculiarities of clutter he can frame in his viewfinder set up a near parity between nude bodies and patterned bedspreads. The models, who were paid, posed in their own homes, and we become as familiar with their lamps and radiators and lace curtains as with their ankles and belly buttons. Consider their hair. Friedlander's nudes add up to a kind of disorganized treatise on hair—armpit hair, leg hair, pubic hair, even head hair—in which bodies may be as scribbled over and textured as fabrics. Put a nude in a picture and she (or he) will hold your gaze, but these women, like some of Matisse's more anonymous odalisques, tend to merge with their surroundings. They could be said to be reduced to objects, but not to sex objects.

Friedlander is clearly knowledgeable about art. Henri Matisse lives in many of these compositions, as does the memory of Jean Arp's swelling sculptural forms, and occasional homage is paid to Gustav Klimt and Egon Schiele, Edward Weston and Bill Brandt. The closest Friedlander has come to the subject of nudes before this was when he bought

E.J. Bellocq's plates and printed them: pictures of prostitutes, taken around 1912, apparently for the photographer's private delectation. Bellocq's women are just as comfortable, just as enmeshed in their settings as Friedlander's; they loll and pose on flowered chaises and oriental carpets in the pseudo-bourgeois elegance of their New Orleans bordello. They present themselves to the camera, however, as to a customer, some tempting, some displaying, in black stockings and scanty shifts or masks. Bellocq's gentle Edwardian pictures about sex for money are in some ways more loving than the faintly clinical, strenuously experimental examples of the uninterested undressed in Friedlander's book.

The way this book is laid out (very nicely, with fine attention to the relation of facing images) makes it look as if Friedlander began with Weston in mind and soon fell back on his own complex, disjunctive aesthetic. The project took twelve years, off and on, but has the coherence of an accomplished style and a unified vision; a key to the achievement of these pictures is that, whatever their references, they end up looking like Friedlanders. His disengagement overrides the effects his concentration on rarely seen parts of the anatomy might

have produced; many images are unlikely blends of intimacy and detachment. Most strike me as much more passionate about the way the lens can record forms in their surroundings than they are about flesh.

For all his curiosity about female genitalia, Friedlander maintains his emotional distance. The models not only are totally unembarrassed before him (and us), but some are so relaxed they have fallen asleep. Almost no one looks at the camera, and many are faceless or headless. Despite arduous efforts to spread their legs they make no effort to entice; they seem indifferent to the male regard. Friedlander goes to great lengths to lower the temperature by contradicting the standard sexual appeal of the nude, and ends up making photographs that are not so much about sex as about anatomy.

Anatomy being what it is, the genitalia of the frontal female nude are effectively hidden from view, and for most of our history art took pains to keep them so. Greek sculptors not only made the *mons veneris* hairless—for Greek women burned off their body hair with a mixture of spices—but eliminated the central cleft, so that even a woman's visible privates were reduced to a pure blank geometry. From the Renaissance onward, propriety demanded that art suppress female pubic hair; the ideal woman had neither genitalia nor any disruptive traces of adult sexuality. The story is told of one highly educated nineteenth-century gentleman who was so stunned by the sight of his wife's body on their wedding night that he sued for an annulment.

In the twentieth century, both art and photography have acknowledged the existence of pubic hair, but except in hard- and soft-core pornography the vulva usually remained hidden, as indeed it does in most of life's ordinary postures. (Rodin exposed it rather ingeniously; Iris, the messenger goddess, raised one leg with her hand as she flew.) Friedlander fully indulges his curiosity about women's secrets in these pictures, which are so explicit that I have heard a couple of men profess embarrassment. For the record, I'm not embarrassed, nor do I see anything wrong with male curiosity

about female anatomy, but no doubt some will think these pictures exploitative and/or pornographic, two words that increasingly elude a consensus definition. The line between art and pornography is extremely thin, as Robert Mapplethorpe made clear, and there are the double issues of the photographer's intention and the viewer's reaction. As to

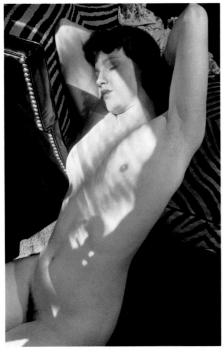

Lee Friedlander, *Untitled*

intent, Friedlander's art credentials were impeccable and his models were consenting adults, fully aware of what was visible between their legs when they parted them, and so far as I can tell entirely undamaged by the images. As to reaction, my aesthetic pulse reacted more strongly than the one in my wrist; yours may react differently.

Although I have no moral qualms about Friedlander's preoccupation with women's private parts, it has produced some of the least successful images in the book, images of women putting themselves into improbably acrobatic postures to expose the pudenda. Bending over to touch the floor and raising one leg in the air, or lying on one side with the

legs stretched out at right angles from the body—the positions are forced and the aesthetic gains nil. Friedlander may have reinvented the nude, but in these instances and some others he tried too hard, and the machinery of invention creaked.

Poses and composition upset the expectations set down both by art and by titillation magazines, and every suntan mark, every scar and bruise and Band-Aid, each mole and trace of arm and leg hair is carefully preserved by his relentless flash, so that even the headless figures remind us we are looking at pictures of real women, not sex goddesses or airbrushed fantasies. (The book has four pictures of our newest sex object, Madonna, in an earlier incarnation when she supplemented her income as an artist's model. The new parlor game consists of trying to identify her.) One of the best aspects of this work from my (female) point of view is that, even though all the women are relatively young, several have a bit too much flesh or fairly small breasts and would never make it in *Playboy*, yet the photographer apparently finds them all equally interesting.

The best images prove to be adventurous reappraisals of the female body. (I especially liked two odd views of a breast and part of a face.) The mere fact that the clothed photographer coolly dominated his naked subjects makes one pause, but I for one am unwilling to renounce even for a worthy principle such beauties as Titian and Goya and Ingres created. I think Friedlander's insistence that women are both real and various, subject to banging their shins and eating too much, neither made of plastic nor modeled on Barbie dolls, is a step in the right direction. As formal explorations these pictures work ingeniously, as nudes they often present the body in an unexpected aspect, and they add a new dimension to the work of a man who has not always photographed the human element as revealingly as the manufactured one. Friedlander's career has had its dull moments, but this is not one of them; you might not like these pictures, but I doubt that you will be bored.

DAVID SALLE: PHOTOGRAPHIC SYMPTOMS
By Donald Kuspit

The psychological meanings suggested by the photographs are so overt that one might almost compose a case report on them—and their maker: *Subject's name*: Salle, David. *Profession*: artist. *Symptom*: obsession with woman, as evidenced in paintings and photographs. *Suggestion of meaning*: a counterphobic response to threatening *femme fatale*. Salle flirts with danger, a fly dancing in and out of the Venus's-flytrap. He becomes a "hit-and-run lover," in Karl Stern's wonderful phrase. But what's the character of the confused, anxious love, of the fear of woman his pictures suggest?

In the end it's a sort of perverse curiosity: a little boy's fascination with the omnipotent woman, a characteristic pre-Oedipal idea. On the evidence of his pictures, Salle seems unconsciously to enjoy being dominated by the eternally young woman while consciously wanting to dominate her—but he can do so only in perverse fantasy. In five of his photographs shown this fall at New York's Robert Miller Gallery, the woman holds attributes of power, barely disguised phallic symbols—two giant light bulbs, a knife, a violin, a ball. (In characteristic overdetermination, the violin doubles as the emblem of the woman's body, the ball as the representative of her nurturing breast.) Like all fetish objects, these are part-body objects. Salle is never able to get her all together into an integral person.

There's an intimation, too, in those pictures of a perverse notion of sexual relations. One huge bulb, positioned above the woman's buttocks, suggests the possibility of anal intercourse. The other bulb hides her face, confirming the artist's indifference to her as a person—she's no particular woman, just a conventionally attractive body (another sign of an immature sexual attitude). In another photograph the woman squats with a violin between her legs, suggesting the unconscious fantasy that it might fit into

her vagina. The bigger the surrogate penis the better, as in de Sade's fantasies of violent intercourse introducing alien objects into the vagina. Each fantasy is a child's version of the primal scene, of what Mom and Dad do in the bedroom.

But of course the bigger substitute object of intercourse, the profounder the impotence. Does Salle have a gangster's attitude to woman? She's the attractive moll, looks great on his arm, impresses the other boys, but he can't do anything with her in bed except violate her. Will he, finally, in his frustration, turn her own knife on her?

So Salle gives us woman as whore—an old, tiresome, but obviously still very much alive notion. Salle's woman is usually more unclothed than clothed; breasts may be revealed, but not crotch, or vice versa, a provocative division designed to arouse and lure the pervert. At the same time, the sense that her body doesn't hang together acknowledges the artist's destructive attitude to her. Some of Salle's women wear black mesh stockings, a seemingly quaint cliché, but in fact a standard part of the fetish fantasy. With this paraphernalia goes essential anonymity: facelessness, or standard prettiness, which amounts to the same thing. (Salle has the pre-feminist view of woman as a specialist in beauty, a cosmetic entity—all good looks or nothing at all, and good looks make her nothing, a human blank.)

Woman is stylized into sterility by Salle. She becomes pure empty form, especially in one image, a contrast of round nipple and square earring, and another, in which she bends over backwards, making a vulnerable curve. This is final confirmation of the subliminal hatred underlying his ostensible fascination with her. (Perversion, as Robert Stoller famously wrote, is the erotic form of hatred.) But doesn't this make a farce of woman, a secret that the photograph of her in clown's costume seems to give away? There's something comic—all too ironical—in the two images in which she's completely covered by a sheet. (Is she in fact under it? Salle mocks what goes on in bed in these works. Rumpled sheets don't

necessarily mean great sex.) She's absurdly obscure, enigmatic.

Does Salle slyly, consciously, manufacture these symptoms in an attempt to make some larger statement? Perhaps, but the female object recurs, demonstrating his fixation on the eternal feminine, however sardonic he may be about it. He may carry a social formula of woman to an absurd extreme, attempting to make its trivialization of her all the more evident, but that only confirms his own hostility to her, a hostility that masquerades as cool detachment. Salle's photographs, with their mechanical black-and-white look, seem, like his women, produced according to formula. Indeed, they seem like caricatures of photography. Salle's nihilistic attitude to his medium as well as woman is as much an indication

of fear of faltering creativity as of faltering sexuality.

Salle's photographs are in fact better symptoms of his psyche than his paintings. He may be following a formula in both his concept of woman and his method of image-making, but a formula is a kind of basic staging of a phenomenon. In comparison to the overelaborated compositions and surfaces of his paintings, his photographs seem straightforward enactments of his grand obsession—they present it in its basic form, as it were. Also, Salle is more able to create the illusion of dominating his female subject matter as a photographer than as a painter, because in the photographs he seems to be dealing entirely in externals and thus to be more in control. In the paintings he creates a more subjectively

David Salle, *Untitled*, 1980–90

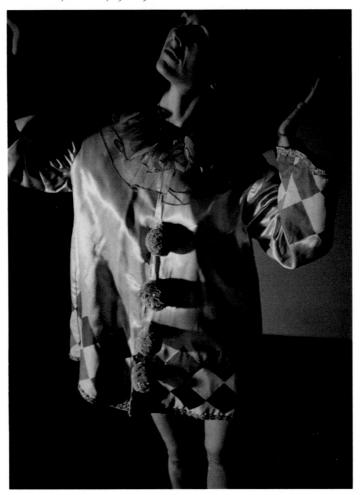

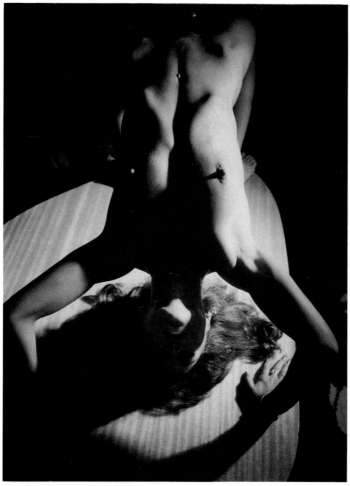

David Salle, *Untitled*, 1980–90

charged, unpredictable atmosphere, through the peculiar "edginess" of his surface and juxtapositions of the images of women with other images from popular culture—cartoons, advertising, kitsch painting, and the like. The paintings transcend Salle's manipulativeness, while the photographs are manipulated to the point of dullness. The argument can be made that they are merely studies for the paintings; but using photography as a kind of preliminary drawing for painting is yet another way of selling its artistic possibilities short.

Despite this, they are a relief after the paintings, which are institutional avant-garde art as its most stifling. Indeed, his dependence on the image of semi-illicit woman, as though her sexiness might rub off on his art and make it as provocative and "criminal" as she seems to be, is a way of distracting us from the crisis visible in his art, which is a sum of bankrupt avant-garde techniques that do not even add up to an ironical innovation. In other words, he looks to a cliché of woman to buttress the cliché of the avant-garde. In any case, the forced, perhaps tongue-in-cheek conventionality and fake luridness of the photographs offer a welcome alternative to the intellectual pretentiousness of the paintings. Compared to them, the photographs take no risks, but then the risks the paintings take have already become old artistic habits.

Are the photographs, then, retreads of a pornographic formula? Not exactly. Instead they are calculatedly banal, which makes them ironically innocent. As I have suggested, this is refreshing after the faux sophistication and self-appointed superiority of Salle's paintings. Moreover, the standardized, even ritualized character of the eroticism in the photographs makes a case for them as symptoms of a pathological attitude to woman that is societal, and not specific to Salle. These photographs suggest man's collective blindness to woman—his one-dimensional view of her.

In implying this, is Salle thus a feminist, and are the more or less naked women who pose for him so casually and indifferently as much the victims of old beliefs about women's nature as men? Is Salle's imagery an oblique attack on women who believe the cliché about their inherent seductiveness, and use it to exploit men and themselves?

ACKNOWLEDGMENTS

A great many people have helped make "The Encompassing Eye: Photography as Drawing" possible. Thanks are due first and foremost to the photographers and writers involved in the project, for their beautiful and thought-provoking contributions.

In addition, sincere thanks for advice and support go to: Weston Naef, J. Paul Getty Museum; Merry Foresta, National Museum of American Art; Jack Shear; David White; Sylvia Wolf, Art Institute of Chicago; Anne W. Tucker, Houston Museum of Fine Arts; Virginia Zabriskie, Zabriskie Gallery; Peter MacGill, Pace MacGill Gallery; Howard Read and Mary Doerhoefer, Robert Miller Gallery; Susanna Wenniger, Laurence Miller Galley; Julie Saul, Lieberman and Saul Gallery; Hans Kraus, Jr.; Sean Devlin; Anne Philbin, the Drawing Center; Mark Haworth-Booth, Victoria and Albert Museum; Lucien Treillard; Koko Yamagishi; Diana Dupont; Graham Howe; Roger Shattuck; Michael Jones, Emily Davis Gallery; and Michael E. Hoffman. A special thanks, for ideas, time, and effort, goes to Raymond Foye, Hanuman Editions.

CONTRIBUTORS

MERRY FORESTA is Curator at the National Museum of American Art, Smithsonian Institution, Washington, D.C. She curated the 1988 retrospective, "Perpetual Motif: The Art of Man Ray" and recently co-curated "Man Ray in Fashion." She is preparing an exhibition of contemporary American landscape photography, entitled "Between Home and Heaven," to be presented in 1992.

VICKI GOLDBERG is a photography and art critic who lives in New York. She is the author of *Margaret Bourke-White: A Biography* (Addison-Wesley, 1987), and *The Power of Photography: How Photographs Changed Our Lives*, recently published by Abbeville.

MICHAEL GRAY is curator of the Fox Talbot Museum at Lacock Abbey and the former head of the photography department at the Bath Academy of Art. He and his wife, Barbara Gray, make prints using original processes from rare early negatives for international exhibitions.

ROBERT HARBISON lives in London, where he teaches at two schools of architecture. He is the author of *Eccentric Spaces* (Knopf, 1977), *The Built, the Unbuilt, and the Unbuildable* (Cambridge/MIT Press, 1991), and other books about cultural history.

DONALD KUSPIT is professor of art history and philosophy at the State University of New York at Stony Brook, and Andrew Dixon White professor at large at Cornell University. His recent books include *New Subjectivism: Art in the 1980s* (Ann Arbor UMI Research Press, 1989) and *Alex Katz: Night Paintings* (Harry N. Abrams, 1991).

WESTON NAEF is Curator of Photographs at The J. Paul Getty Museum, Malibu, California. He has recently organized the exhibitions "August Sander: Faces of the German People" from the Getty Museum holdings and "Atget's Magical Analysis: Photographs 1915–1927." He is presently at work on a two-volume survey of the Getty Museum photographs collection.

For over twenty-five years GRAHAM NASH has received international renown as singer, musician, and songwriter with the Hollies and Crosby Stills & Nash. An avid art collector and photographer, he is currently publisher of Nash Editions, a visual-arts workshop established to promote collaboration between artists and computer-generated digital technologies.

CARTER RATCLIFF is a contributing editor of *Art in America*. His latest book is *Komar and Melamid*, published by Abbeville in 1989. He is also author of *Andy Warhol* (Abbeville, 1984).

DONALD SAFF is a Distinguished Professor and Dean Emeritus at the University of South Florida, Tampa. For the last eight years, in addition to directing Graphicstudio, which he founded in 1968, he was artistic director for the Rauschenberg Overseas Culture Interchange (ROCI). He has written essays on Jim Dine, Roy Lichtenstein, and James Rosenquist.

TOSHIO SHIBATA was born in Tokyo in 1949. He received his B.A. and M.F.A. at Tokyo University of Fine Arts and Music and later studied graphic art and photography at the Royal Academy of Ghent. He currently lectures in photography at the Tokyo College of Photography.

SALGADO, RIBOUD, MARK, DOISNEAU

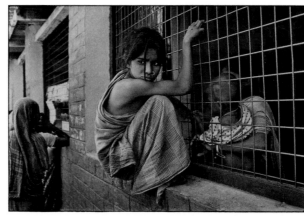

Mary Ellen Mark
Calcutta, 1981

We are offering works by these four photographers, and several others when you make a donation to the Mother Jones International Fund for Documentary Photography.

Your donation directly supports new international photography, and expands the channels through which such work reaches the public. You join a group of committed photographers, curators, editors, educators, and collectors who are facilitating this dynamic new world photography.

Your donation also makes you eligible for discounts on selected fine photography books.

For a free brochure describing these and other benefits, write: Beth A. Schoenfeld, **Mother Jones Fine Print Program**, 1663 Mission Street, San Francisco, CA 94103. Or call (415) 558-8881. Our fax is (415) 863 5136. The number of prints is limited. Please call or write today.

Granta—the British Quarterly of International Writing and Photography

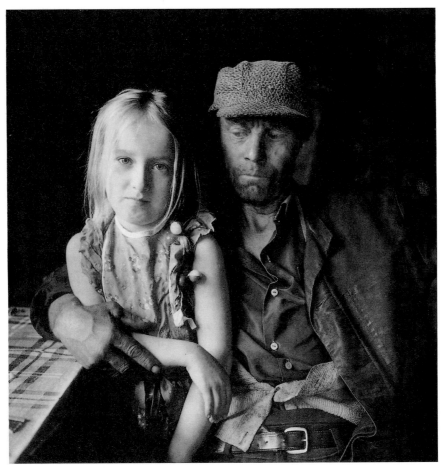

Inka Ruka

New fiction. Provocative photography. Travel writing. Exclusive interviews.

By the leading artists of the day—Mario Vargas Llosa, Don McCullin, Martin Amis, Inka Ruka, Salman Rushdie, Gilles Peress, Gabriel Garcia Marquez, Margaret Atwood, Alex Kayser, T.C.Boyle, Richard Ford, Simon Schama, Eugene Richards and others.

In bookstores or by subscription—$19.95 introductory offer for one year (4 issues).

US Office: 250 West 57th Street, Suite 1316, New York, NY 10107
Telephone: 212/246-1313 Fax 212/333-5374

Toward A Truer Life

PHOTOGRAPHS OF CHINA 1980-1990
By Reagan Louie
Introduction by Jonathan D. Spence

Cadres and Portrait of Lenin, Yaboli, 1987

Vividly spanning the period from Mao's last days and the first tentative experiments with democracy to the tragic regression of Tiananmen Square, *Toward a Truer Life:* Photographs of China 1980-1990 is both an unprecedented record of China's struggle for modernity and an intensely personal odyssey of a young Chinese-American's search for his roots.

Award-winning photographer Reagan Louie returned to the land of his ancestors many times during the 1980s. Covering every province and region without standing out as a Westerner, he photographed the Chinese people in the totalitarian gray of Maoism, in the bright hues of China embracing democracy, and in the carnage and valor of Tiananmen Square. The wonder, rage and enchantment of the period are captured in the book's seventy-six unforgettable full-color photographs. Remote villages seemingly untouched by progress. Young city people clad in image-conscious fashions. Soldiers toiling on the plain beneath Tibet's sacred Potala Palace.

Demonstrating masterful artistry, Reagan Louie combines the idiosyncratic realism of Cartier-Bresson with the social individualism of Walker Evans to make photographs that have universal appeal and lasting historical interest.

Limited Edition

Out of Louie's personal production run of fifty cloth-bound volumes, nine limited editions are being offered to collectors. Each book is protected in an embossed slipcase. Included with the edition is an exhibition quality color print of the hard cover edition's cover photo: *Cadres and Portrait of Lenin*, Yaboli, 1987 (shown above). The 24x20″ photograph was personally printed by Reagan Louie and, like the book, is signed by him.
96 pages. 11 x 9½″. Image measures 23 x 19″. $900.00.

Master Set of Prints

A unique Master Set of twenty 24x20″ exhibition quality prints from the book, each personally printed and signed by Reagan Louie, has been donated to the Aperture Foundation. Aperture is offering the set for sale so that the funds can be used to help underwrite the cost of publication.

For further information, or to arrange a viewing, write: Reagan Louie Collection, 20 East 23rd Street, New York, N.Y. 10010. Telephone (212) 505-5555. $17,000.

Reagan Louie holds degrees from the University of California, Los Angeles, and from Yale University. He is presently associate professor of photography at the San Francisco Art Institute. His work has been exhibited widely and is in the permanent collections of major museums around the world. Among his many awards, Louie has received a National Endowment for the Arts grant and a John Simon Guggenheim Fellowship. A traveling exhibition of his photographs, organized by The Friends of Photography, opened at the Ansel Adams Center in San Francisco in July 1991.

Roberto Galindo © 1990

"Throughout, Louie's photographs delight with so rich and right a sense of color that we can only marvel."

Maria Morris Hambourg
Associate Curator, Department
of Prints and Photographs
The Metropolitan Museum of Art